IMAGES
of Rail

LOST TROLLEYS OF
QUEENS AND LONG ISLAND

On the cover: The Jamaica-Flushing line of the New York and Queens Railway was a delightful surprise to city dwellers from Manhattan and the Bronx. The thought that a countrified trolley operation existed within the confines of metropolitan New York was mind-boggling. Street railway enthusiasts used to call the line "the interurban in the city." And so it was. (Courtesy of the Author's collection.)

IMAGES
of Rail

LOST TROLLEYS OF
QUEENS AND LONG ISLAND

Stephen L. Meyers

ARCADIA
PUBLISHING

Published by Arcadia Publishing
Charleston SC, Chicago IL, Portsmouth NH, San Francisco CA

Printed in the United States of America

Library of Congress Catalog Card Number: 2006924313

For all general information contact Arcadia Publishing at:
Telephone 843-853-2070
Fax 843-853-0044
E-mail sales@arcadiapublishing.com
For customer service and orders:
Toll-Free 1-888-313-2665

Visit us on the Internet at http://www.arcadiapublishing.com

To my late brother, Benjamin "Jim" Meyers, who was always amazed that I liked trolleys but joined in my enthusiasm, and to my wife, Sandra, who, before we were married and standing in snow up to her knees waiting to get that special photograph, realized it must be love. So, after almost 25 years of wedded rail fanning, we both agree.

CONTENTS

INTRODUCTION

The landmass commonly identified as the boroughs of Brooklyn and Queens and the suburban counties of Nassau and Suffolk has, somewhat inelegantly, been described as looking like a fish whose head has been bitten off, with the outer end of the island resembling the fish's tail, the intermediate section the fish's body, and the western portion, including Brooklyn and Queens, as to where the missing head should be.

The geographic description of Long Island is very distinct with the north shore being dotted with cliffs, promontories, bays, and indented hill-bounded harbors. The south shore, facing the Atlantic Ocean, is uniformly lower with miles of protective sandbar islands, sheltering shallow bays and many benign harbors. The east end, including parts of Nassau and Suffolk Counties and all of Brooklyn and Queens, is a fully integrated section of the New York City megalopolitan complex. To a great extent, the topography was a major influence on how the area developed and explained the philosophies of the construction of the streetcar companies.

When the Long Island Rail Road's antecedent companies built along the north shore, they early decided that it would be impractical to divert their lines to each port or harbor fronting Long Island Sound. So they built their lines relatively straight in an east-west configuration, effectively missing the population centers. The railroad quickly realized this and ultimately became the owners of a number of short trolley companies that connected the towns to the somewhat distant railroad stations.

The straighter and more easily accessible south shore communities complemented their steam railroad services with a number of short street railway lines connecting the many adjacent villages. In addition, there was one major trolley line that built a cross-island line connecting the north and south shores.

As the steam lines got closer to the New York City line, a network of suburban trolley companies connected the many towns and villages with the steam railroads and trolley and rapid transit lines centered around Flushing and Jamaica. And finally, there were the major street railways in western Brooklyn and Queens that moved both local and semisuburban passengers to the ferries and bridges connecting Long Island with Manhattan. All of these lines had their own personalities, even those companies whose operating strategies were actually dictated by the twin major transit operators: the Long Island Rail Road and the Interborough Rapid Transit Company, both of which influenced widespread major trolley operations in many unexpected areas. And finally, that Brooklyn behemoth, the Brooklyn Rapid Transit, surprisingly spun some steel-railed webs of its own in Queens—all in all, a heady mix of transit.

While some readers may consider these trolley lines quaint, they must be viewed in the time frame of the generation between 1890 and 1910. In those days, people living in a small country town and wishing to travel to adjoining towns or villages found the choice of local transport was extremely limited. They might walk, ride a horse, travel in the family rig, use a bicycle (very popular at that time), take a train if one was available, or ride the newfangled, inexpensive, frequent trolleys, the travel mode of their time. Only a few rather wealthy people owned automobiles, but they were not considered particularly practical, especially on those unpaved roads. So the trolley afforded convenient local travel to all for the very first time. It may not sound like much today, but in those days, it was a major social and economic factor and had a lasting effect on the entire area.

Any historical survey of Queens and especially of the long gone or Long Island trolleys must rely on the research, writing, and recollections of many people. The historical information herein is mainly based on the writings of Vincent Seyfried and his late father-in-law, Felix Reifschneider. Without their works as a basic resource, there is no way this book would have been written. Photographs in this book come mainly from the author's own collection, which includes examples of the work and/or collections of Vincent Seyfried, Pete Ascher, the late Joe Diaz, the late Will V. Faxon Jr., the late Francis (Frank) Goldsmith, and Alfred Seibel, among others. And finally, kudos to Bernard Linder and Henry Pech for their invaluable map drawings.

For further information about these lines, I enthusiastically recommend the writings of Vincent Seyfried, Felix Reifschneider, and Harold E. Cox.

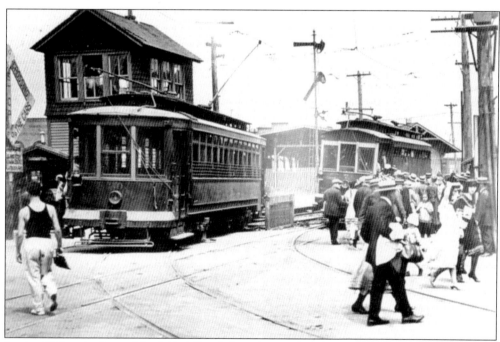

In the 1920s, the Long Island Rail Road shared its right-of-way and third rail power source between Far Rockaway and Hammels with its sibling Ocean Electric Railway. At Hammels, the trolley line became a true streetcar operation by entering its own line for street running to Beach 116th Street in Rockaway Park and later continuing on to Neponsit. Keep a sharp eye out for the potentially deadly combination of raised trolley pole and lowered third rail shoe. There obviously was no Occupational Safety and Health Administration in those days.

One

THE NEW YORK AND QUEENS COUNTY RAILWAY

The largest independent street railway to operate in Queens was the New York and Queens County Railway, which had lines in Long Island City, Woodside, Astoria, Flushing, College Point, North Beach, and Jamaica and served Manhattan via a line over the Queensborough Bridge.

The New York and Queens County system had expanded to its final size in 1896 when it took over the lines of the original Steinway Railway Company in western Queens. When the Steinway (piano) interests received a franchise to build a railway tunnel under the East River as the New York and Long Island Railway, the New York and Queens County was determined to be the operator. Two of the main conditions were to electrify the line and to operate multiple unit streetcars through the tunnel to a terminal situated just beneath Manhattan's Grand Central Terminal. Therefore, the company purchased a fleet of 50 heavy, end-door, multiple-unit streetcars in 1906 from J. G. Brill and American Car and Foundry for exclusive use in the tunnel. The cars were of steel construction and were built with heavy motors to overcome the grades leading into and out of the actual tunnels. On September 22, 1907, a single car was operated on the tunnel line, but the trolleys never again used that expensive property. It lay fallow until 1915 when the twin tubes were incorporated in the Interborough Rapid Transit Company's Flushing rapid transit line. However, for all those years, the New York and Queens County was saddled with those heavy multiple unit (MU) streetcars, which were really much too weighty for the mainly street running of the company and were extremely expensive to operate due to their inordinate appetite for electricity. In 1909, the New York and Queens County finally got its entry into Manhattan via service on the newly opened Queensborough Bridge. Note that the aforementioned Interborough Rapid Transit had a major hand in Queens and Long Island traction, which will be discussed subsequently.

In 1922, the New York and Queens County fell into bankruptcy and was restructured with the former Steinway Railway's lines becoming independent once again. A reconstituted company, now called the Steinway Lines, ultimately under the stewardship of the Third Avenue Railway, ran mainly in the Long Island City and Astoria area, also taking over the Queensborough Bridge line to Manhattan.

The newly renamed New York and Queens Railway went back to its original size, serving Long Island City, Woodside, Flushing, College Point, and Jamaica with a separate line to the Calvary Cemetery in southwestern Queens. However, one of the main lines that it still operated was the mostly private right-of-way route between Flushing and Jamaica via Kissena Park and Flushing Meadows (more about this line shortly). An oddity about the Borden Avenue line was that after the breakup of the New York and Queens County, the Borden Avenue line was awarded to the New York and Queens Railway. However, there was no track connection to the rest of the system. To gain access to its own Woodside carbarn, the New York and Queens had to petition its former component company, the Steinway Lines, to permit its own cars to travel over Steinway track for carbarn moves.

On June 24, 1930, the huge New York and Queens carbarn at Woodside, which serviced its own cars and those of the Steinway Lines, was destroyed by fire. Lost in the conflagration were 24 of its old wooden deck-roof cars, 10 recently acquired Birney cars, and 13 service cars.

Fortunately 12 cars just purchased from upper New York State's Auburn and Syracuse Railway were outside the building awaiting new livery and were spared. However, the New York and Queens no longer had sufficient cars to cover its service requirements.

Two of New York's transit operators, the nearby Jamaica Central Railways and the New York City Department of Plant and Structures, were able to supply temporary replacements. In addition, the New York and Queens scoured the used trolley market and quickly came up with a total of 35 cars from such recently abandoned properties as the Interstate Street Railway (Attleboro, Massachusetts), the Muskegon (Michigan) Electric Traction, the Bridgeton and Millville (New Jersey) Street Railway, the Susquehanna Transit Company of Lock Haven, Pennsylvania, and, finally, the recently motorized Jamaica Central Railways. The new equipment changed the image from a bedraggled street railway to that of a relatively modern property, and revenues soon began to reflect that change.

Unfortunately the City of New York had hot eyes for the Jamaica-Flushing line right-of-way, planning to build a network of automobile expressways in Queens with that stretch of track considered to be a major element. By the middle of August 1937, pressure from the City of New York finally forced the New York and Queens to substitute buses for its trolleys and give up its coveted transmeadow right-of-way, thereby eliminating New York City's only semblance of an in-the-city interurban operation.

By the end of October 1937, the final New York and Queens rail line, the Calvary Cemetery line, converted to buses. The impact of trolley operations in Queens was down to the impoverished Steinway Lines, and even its time was fast coming to a conclusion.

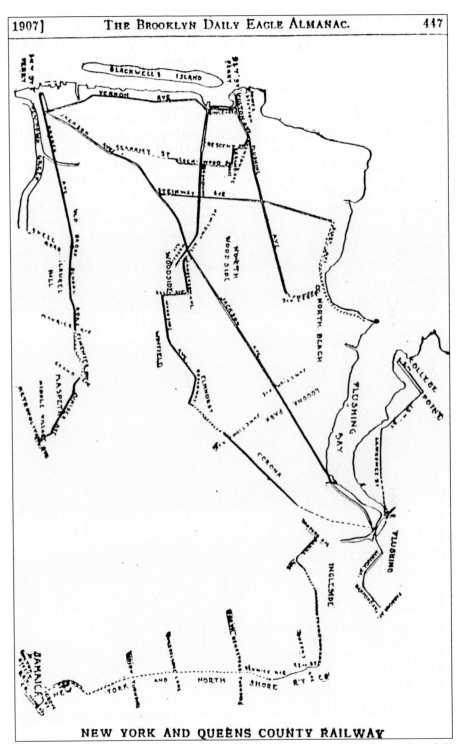

NEW YORK AND QUEENS COUNTY RAILWAY

This *Brooklyn Daily Eagle* almanac map shows the fullest extent of the New York and Queens County Railway. The company was later reorganized as the New York and Queens Railway with the former Steinway Railway lines spun off.

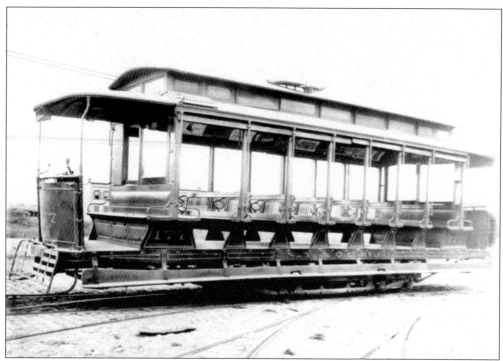

The St. Louis Car Company built 11 cars in the 280–290 series in 1900 for the New York and Queens County. Most were taken out of service before the June 1930 carbarn fire.

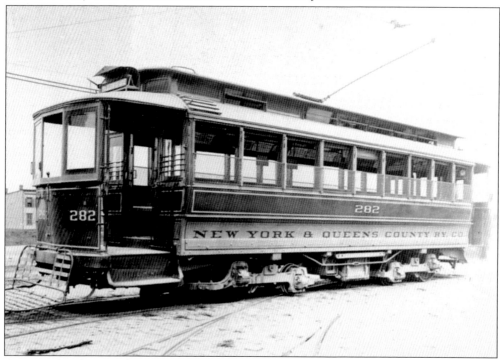

As part of a photographic inventory of its rolling stock, New York and Queens County car No. 177 represented the 100 single-truck open cars in the 130–229 series.

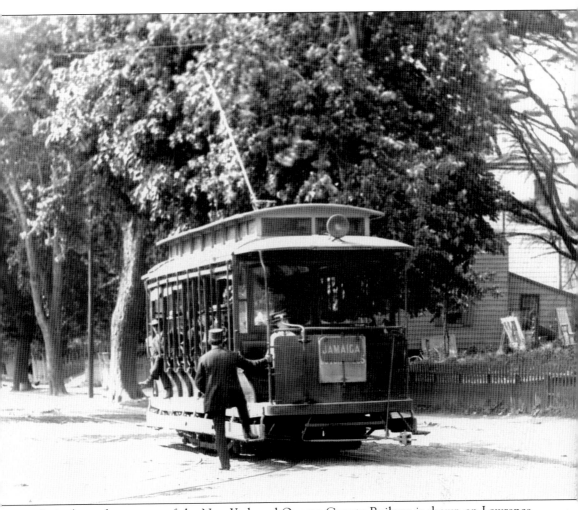

A single-truck open car of the New York and Queens County Railway is shown on Lawrence Avenue (now College Point Boulevard), Flushing, on its way across the swamps and meadows to Jamaica.

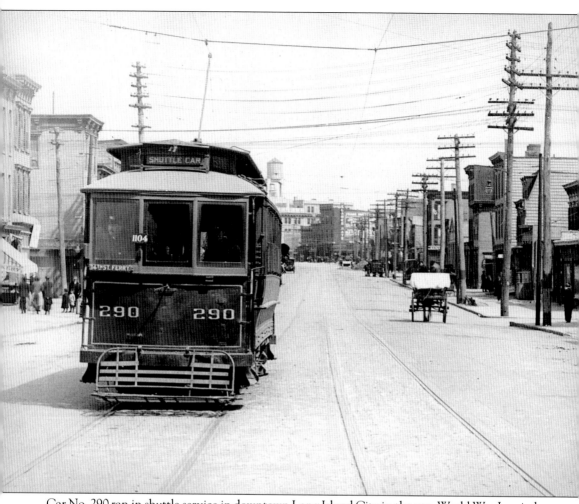

Car No. 290 ran in shuttle service in downtown Long Island City in the pre–World War I period; its destination was the 34th Street ferry terminal linking Queens with Manhattan.

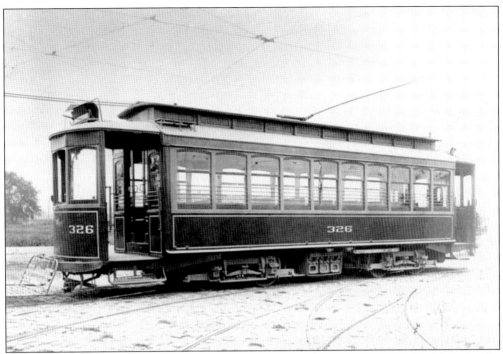

In another inventory photograph, the New York and Queens County's No. 326 poses for the camera. This car series (321–330) was purchased in 1906. In rebuilt form, a few representative cars remained in service until the 1937 end of trolley operation.

This product of the Jewett Car Company was delivered in 1910 and cost a whopping $4,214.16. It ran in updated configuration until 1937 when the successor New York and Queens line quit.

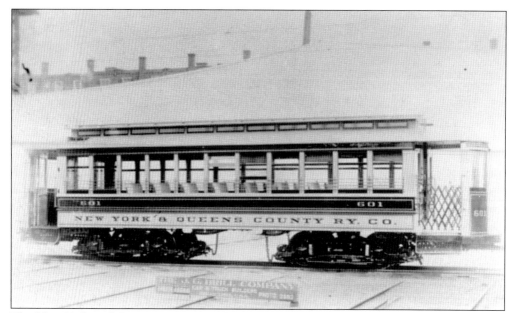

The New York and Queens County Railway was chosen to operate the first streetcar tunnel between Queens and Manhattan. Because of the long underwater run and steep grades, one requirement was the equipment to be used be of extra heavy construction and have multiple-unit control capability. The 50 cars (series 601–650) built for this service were never used in tunnel service except for unit No. 601, which was only used one day. The heavy equipment, extremely expensive to operate, was ultimately consigned to local lines.

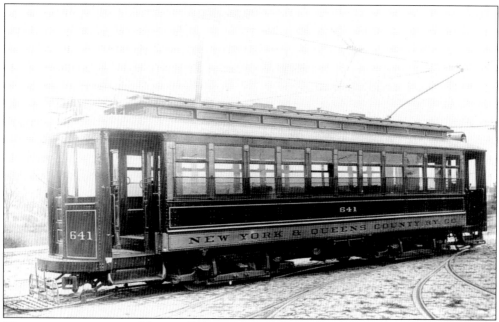

The massive construction of the so-called "tunnel cars" shows up in this portrait of unit No. 641. The 600s were used primarily on the line to North Beach. These cars became a drain on the profitability of the New York and Queens County and probably hastened the company's reorganization.

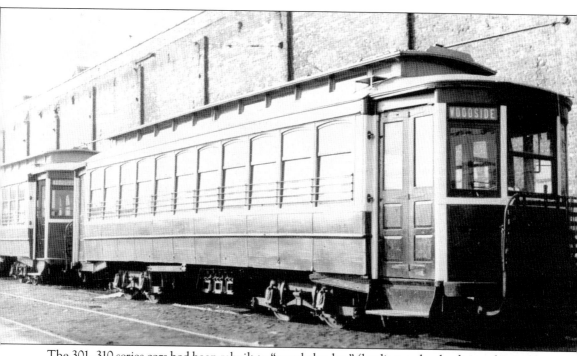

The 301–310 series cars had been rebuilt to "muzzle loaders" (loading and unloading only via the front door) after the New York and Queens Railway inherited them from their original owner, the New York and Queens County Railway.

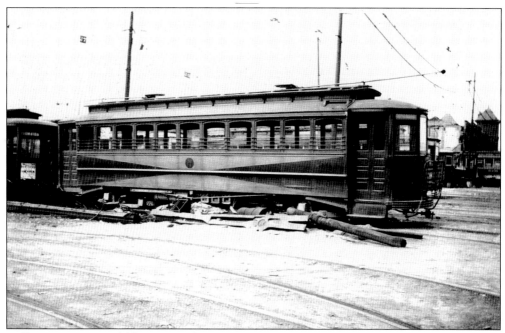

Still in its orange and blue paint scheme, New York and Queens car No. 361 represented the rebuilt version of the 1911-built Jewett series of cars numbered from 341 to 365. It was hard to miss seeing cars with this livery.

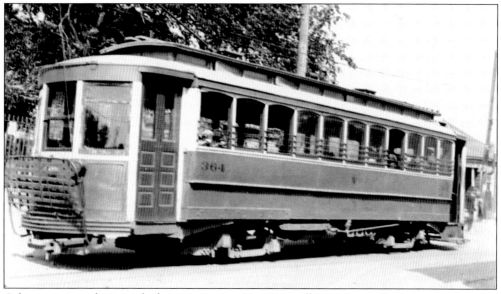

A later version of paint job shows up on car No. 364, still carrying its "passenger scooper," a device cleverly design to scoop up any human being who managed to be in the path of a moving trolley car. It really worked.

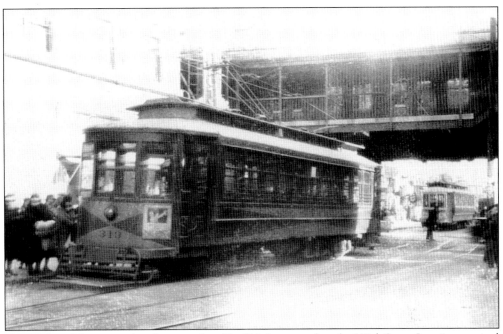

New York and Queens strikingly painted car No. 313 shares track at the 160th Street Jamaica terminal with Jamaica Central car No. 305. They were not very pretty, but they did pull in the passengers.

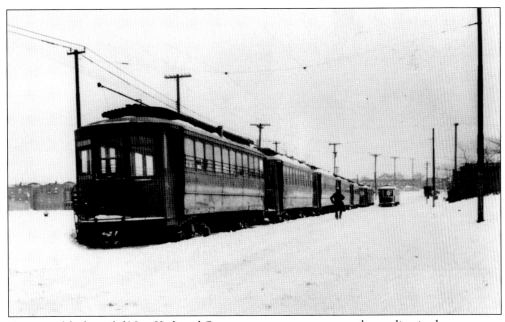

A string of deck-roofed New York and Queens passenger cars are stuck standing in the snow near the Woodside carbarn. Note that the tracks are completely obliterated by the snow.

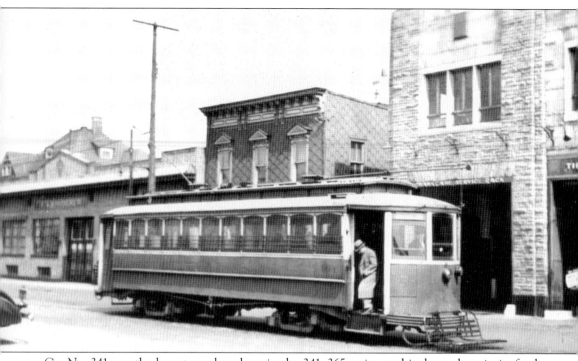

Car No. 341 was the lowest numbered car in the 341–365 series, and is shown here in its final orange livery.

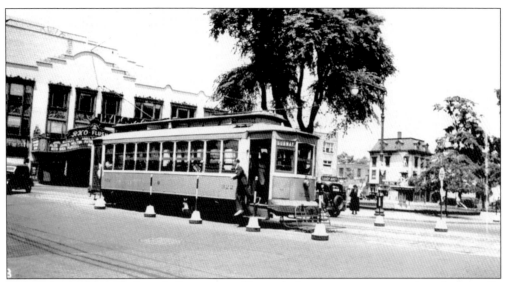

Although the New York and Queens usually used their newest cars on their high-profile Jamaica-Flushing line, it was sometimes necessary to use older cars to cover the runs. Deck roof car No. 322 loads passengers at Main Street in Flushing for the scenic ride to the connecting subway at Jamaica.

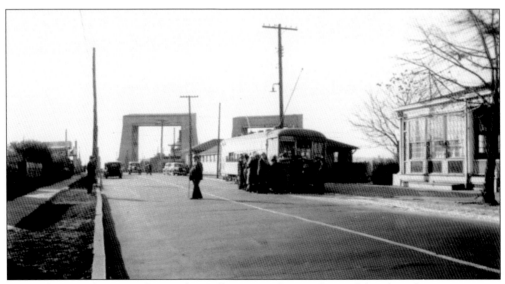

Many photographs were taken at the College Point ferry in front of the glassed-in restaurant at the right. However, here is a picture showing the ferry terminal itself with the slips at the end of the track.

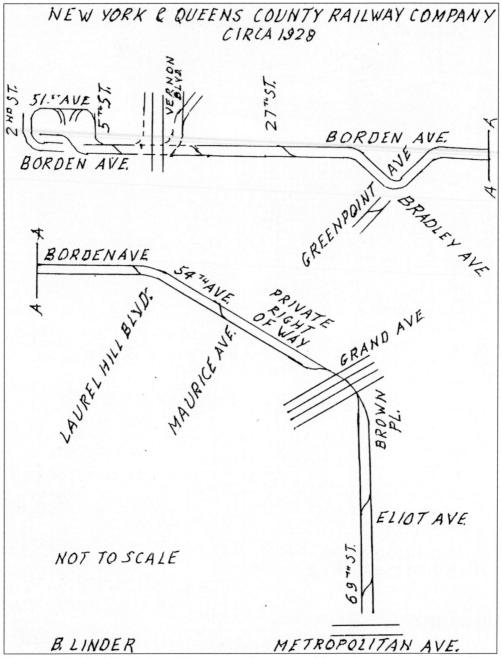

NEW YORK & QUEENS COUNTY RAILWAY COMPANY
CIRCA 1928

2ND ST.

51st AVE

5TH ST.

VERNON BLVD

27TH ST.

BORDEN AVE.

BORDEN AVE.

GREENPOINT AVE.

BRADLEY AVE.

A
A

A
BORDEN AVE
A

54TH AVE.

LAUREL HILL BLVD.

MAURICE AVE.

PRIVATE RIGHT OF WAY

GRAND AVE.

BROWN PL.

ELIOT AVE.

69TH ST.

NOT TO SCALE

B. LINDER

METROPOLITAN AVE.

This section of the New York and Queens was disconnected from the main operation and cars were serviced at the New York and Queens's Woodside barn, reached by a connection via the Steinway Lines.

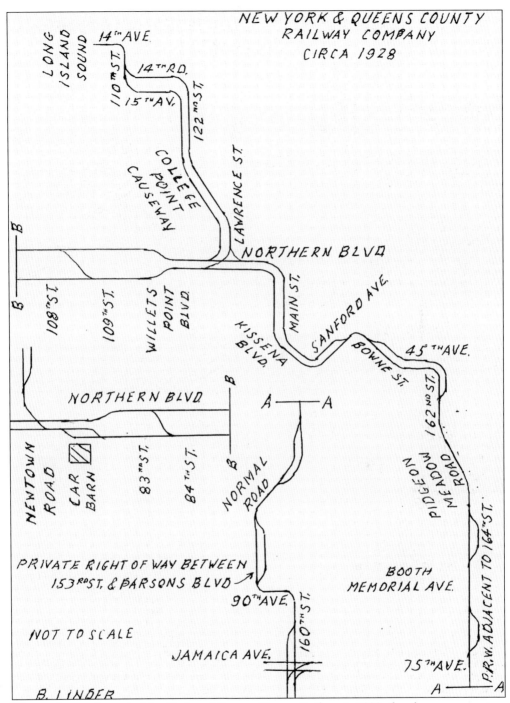

This track map shows the New York and Queens County Railway in 1928 after the reorganization. Note that the long Jamaica-Flushing line was later rebuilt to double track.

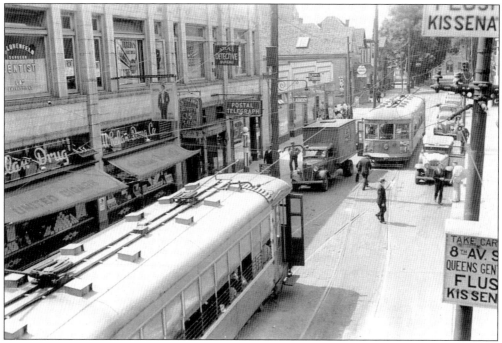

The New York and Queens's Jamaica-Flushing line was often referred to as the city's backyard interurban line because it ran right behind so many houses on its route. The trip, however, started at the Jamaica terminal at 160th Street, just below Jamaica Avenue, shown here with cars lining up for the voyage.

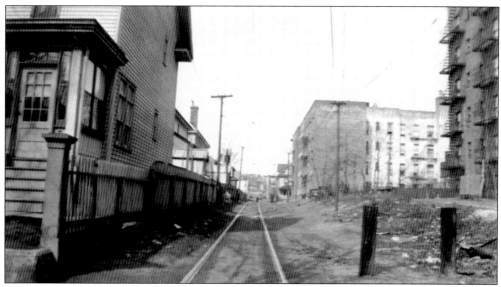

At a point on Ninetieth Avenue, at a point between Parsons Boulevard and 153rd Street, the line turned north, squeaked between some buildings, and suddenly was on its own single-track private right-of-way.

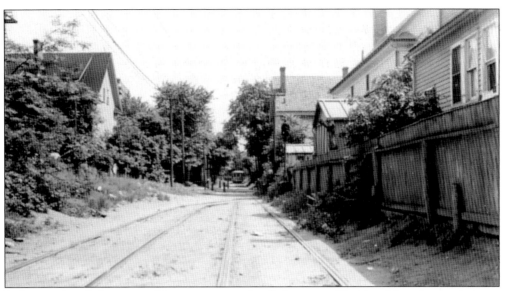

It then made a slight turn and became two tracks all the way to Flushing. Note the proximity to the fenced-in backyards.

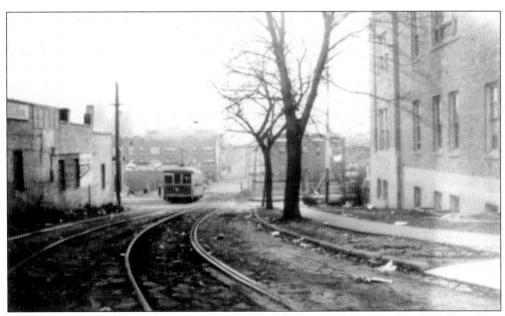

Then the track started a descent that led the line to Kissena Park and Flushing Meadows. Here some apartment buildings gave budding trolley fans a bird's-eye look at the operation.

Homes became farther apart as the narrow right-of-way threaded itself behind some final buildings.

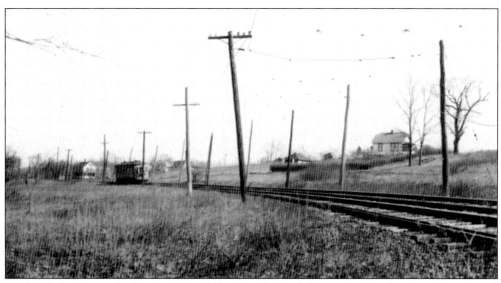

The line, looking now like a light interurban line, made a sweeping turn to the edge of Kissena Meadows.

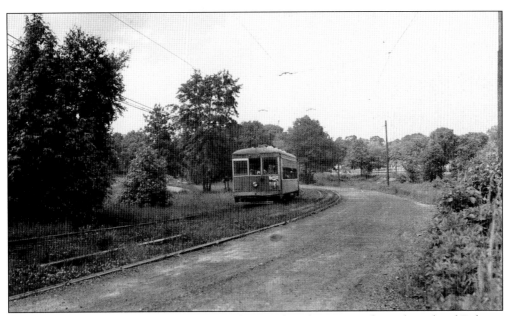

Deep into Kissena Park, the double-track line made a long turn along the side of Pidgeon Meadow Road.

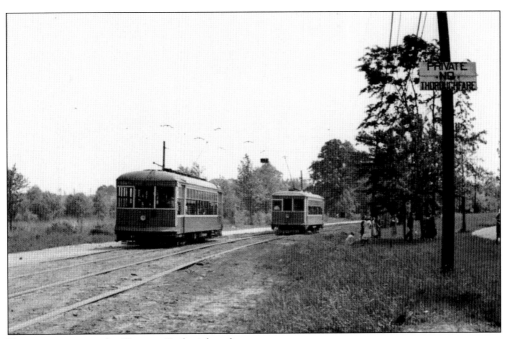

Two cars meet on the Kissena Park right-of-way.

At a sylvan spot along the route, two ladies leave their park bench and board a Flushing-bound car.

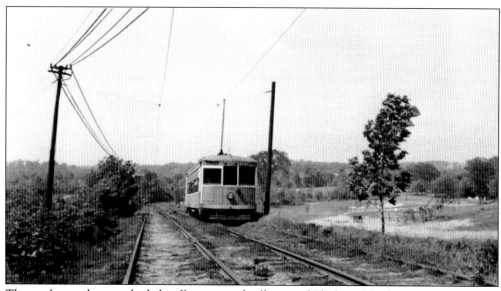

The car leaves the tree-shaded trolley stop and rolls toward Flushing Meadows.

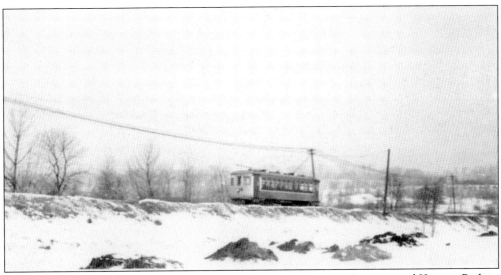

The orange trolley must have been a bright sight sweeping across snow-covered Kissena Park in December 1936. Trolley service ended within a year, and part of this scene changed forever, as the six-lane Grand Central Parkway was built partially on this site.

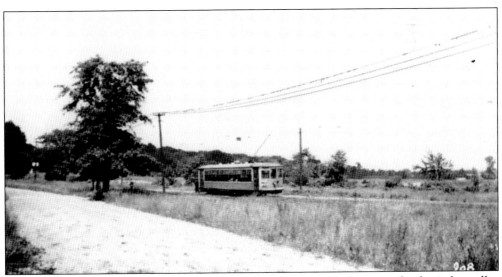

The meadow area was quite barren in those days, with just a meandering road to keep the trolley company. It is hard to believe that part of this area became the site for both the 1939–1940 and the 1964–1965 New York World's Fairs.

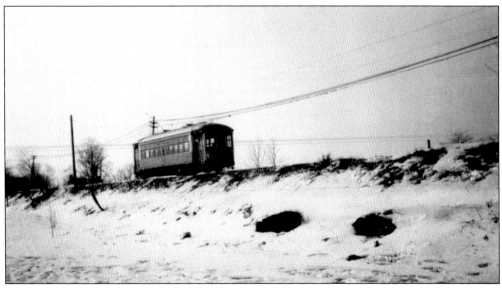

The entire image of the Jamaica-Flushing line changed when the snows came. The line became even more picturesque but much less benign.

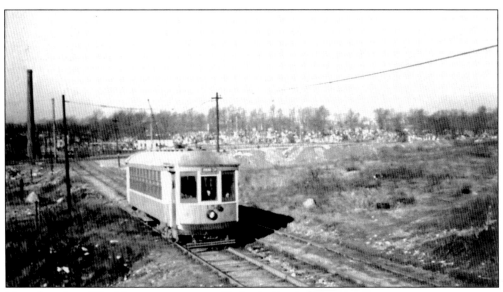

Near the edge of Flushing, a cemetery marks the beginning of the town.

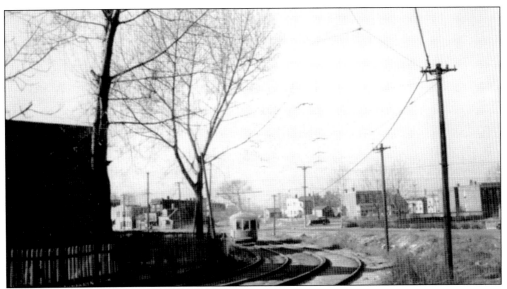

The line makes a tight turn before entering the trackage on Flushing's Main Street, which will continue to the terminal.

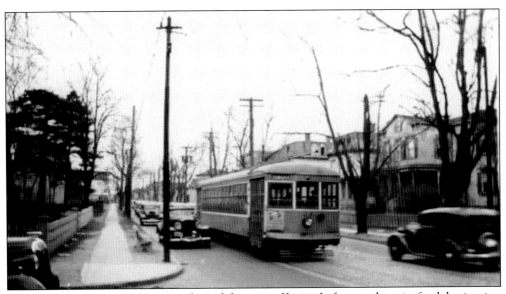

Car No. 24 carefully wends its way through heavy traffic just before reaching its final destination in Flushing.

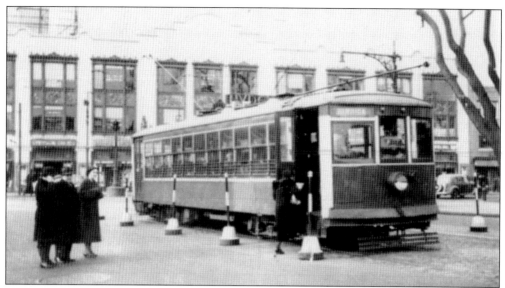

New York and Queens car No. 34 has completed the trip to Flushing and now sits at the intersection of Main Street and Northern Boulevard, awaiting departure of its return trip to Jamaica.

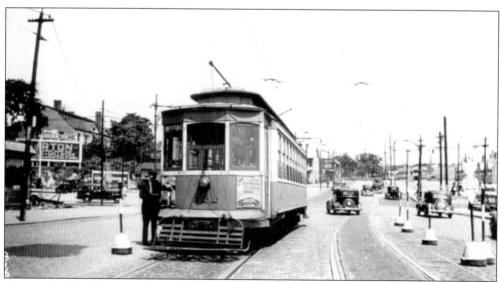

One of the New York and Queens's deck-roof cars rests in the street just before entering relay tracks at Main Street and Northern Boulevard. The company preferred to show its more modern face by usually assigning the newer equipment to this route.

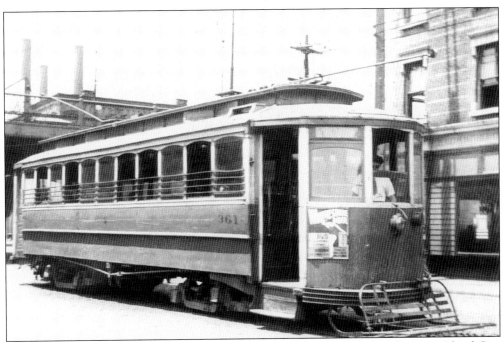

The New York and Queens Railway's long Borden Avenue line ended at the Long Island City yard of the Long Island Rail Road, where such old-timers as No. 361 delivered commuters for further travel.

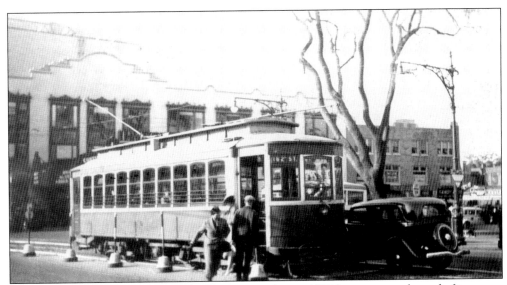

New York and Queens car No. 330 had been around since 1906 but was near the end of its career in this 1936 photographic study. Known as the "small Brills," its family held down some of the routes that required front loading and unloading. Note the lack of rear steps.

Car No. 500 started life as the private car of the line's president, August Belmont. It later was in use as a private car available for charter. Its final use was as the office of the line's superintendent.

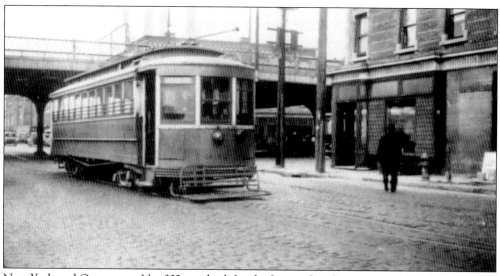

New York and Queens car No. 332 was built by the Jewett Car Company in 1910. It was 1 of 10 cars in the 331–340 series. These cars were very similar to the small Brills.

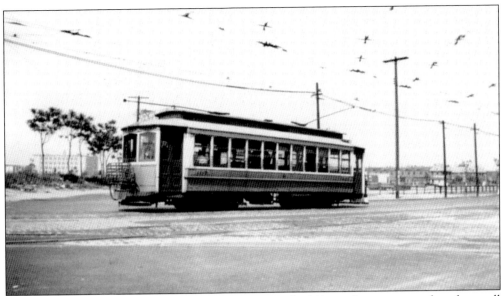

The "big Brills" were distinguishable by having a total of 11 windows, compared to the small Brills, which only had 10.

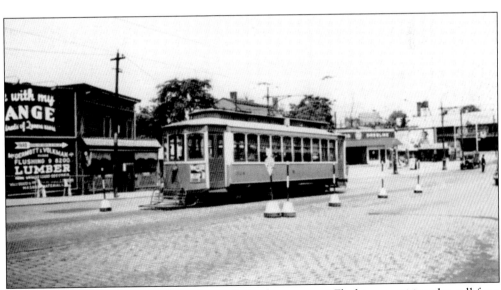

A deck-roof Brill product stands at the ready in the square at Flushing, awaiting the call for a fast trip to Jamaica.

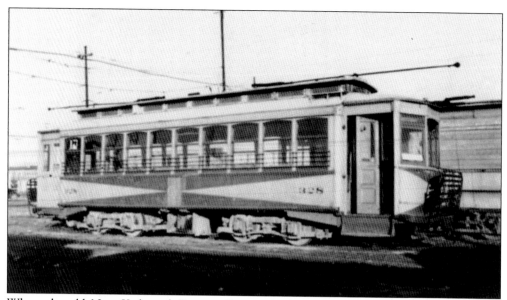

When the old New York and Queens County Railway emerged from reorganization, the rejuvenated New York and Queens Railway distinguished its new identity by painting its cars a flashy orange and blue color scheme. Small Brill car No. 326 shows off the new livery.

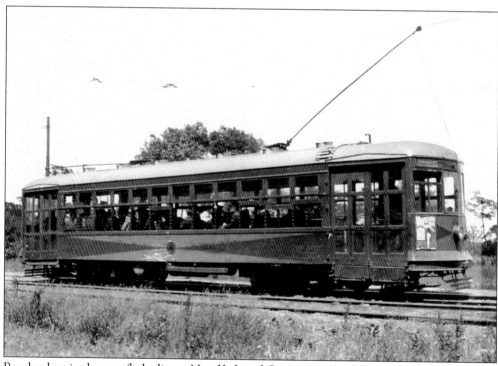

Resplendent in the new flashy livery, New York and Queens car No. 22, an ex–Muskegon Electric Traction Company car, displays its new paint scheme while traversing the Flushing-Jamaica line.

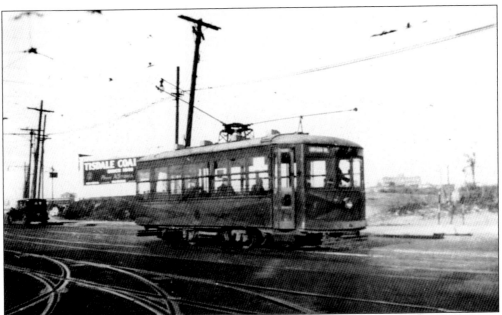

Even the lowly single-truck Birneys were anointed with the blue and orange paint scheme of the new company. Apparently the new image did not catch on in spite of adapting two-thirds of the official colors of the city of New York. Here car No. 44 scuttles down the street near the Woodside carbarn.

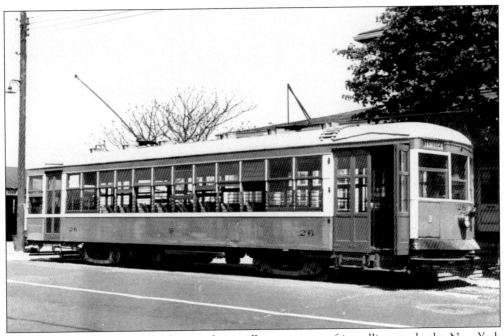

After a disastrous carbarn fire destroyed a goodly percentage of its rolling stock, the New York and Queens embarked on a buying spree to reequip its system with good secondhand cars. One of its first purchases was a fleet of six utilitarian double-truck cars from Muskegon, Michigan. Now numbered in the 21–26 series, car No. 26 shows off in a portrait at the College Point terminal.

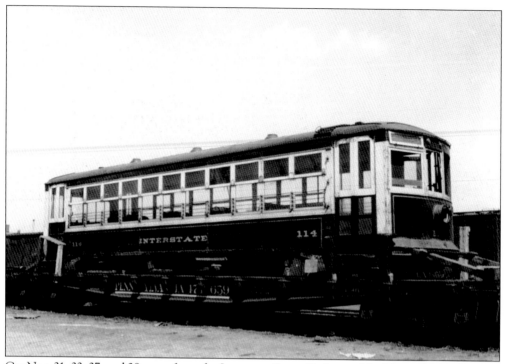

Car Nos. 31–33, 37, and 38 came from the Interstate Street Railway of Attleboro, Massachusetts. Here Interstate car No. 114 is shown being delivered to the New York and Queens.

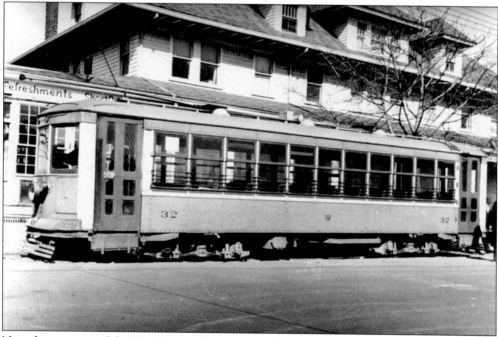

Now the property of the New York and Queens Railway, car No. 32 was originally operated by Attleboro's Interstate Street Railway. Posing in the noonday sun at College Point terminus, the car gleams with pride.

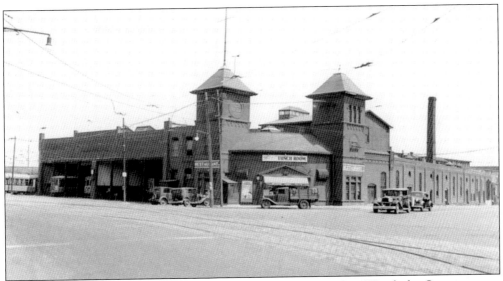

The New York and Queens Railway's carbarn, shops, and yard at Woodside, Queens, was a center of traction activity for years. After the destructive fire of June 24, 1930, the entire west portion of the carbarn was destroyed together with a great deal of rolling stock. The former structure was utilized as an outdoor storage yard until the end of Steinway Lines's service in 1939, Steinway being the last lessee to use the property.

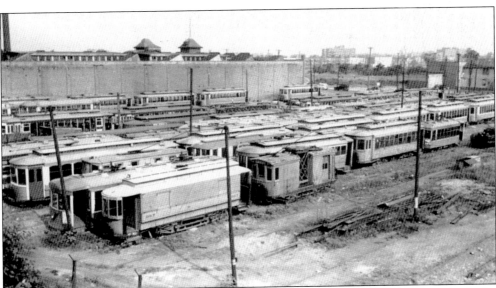

A general view of the storage yard in 1937 shows cars of three different companies. At the far left, against the wall, are cars of the New York and Queens, in the central portion are some convertible cars used in Steinway Lines service, and at the right are derelict cars of the former Jamaica Central Railways.

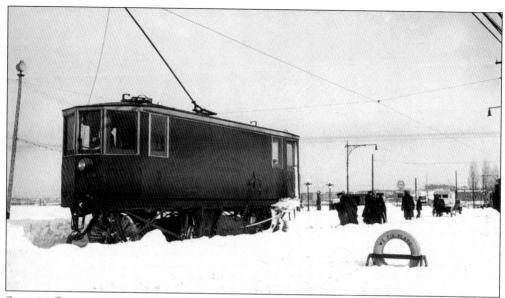

Snow in Queens was never fun for the streetcar companies. Here snow sweeper No. 05 of the New York and Queens Railway is temporarily stalled in the snow on Northern Boulevard. The sweeper was formerly the property of the Jamaica Central Railways.

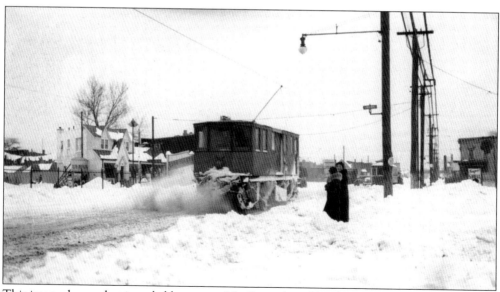

This image shows what is probably sweeper No. 7, purchased by the New York and Queens from the Poughkeepsie and Wappingers Falls Railway of Poughkeepsie, doing its thing on Northern Boulevard at Woodside.

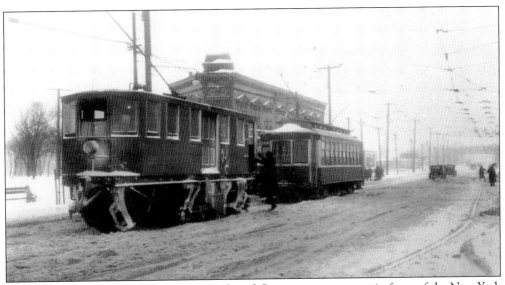

Snow sweeper No. 7 sits behind a New York and Queens passenger car in front of the New York and Queens Woodside carbarn.

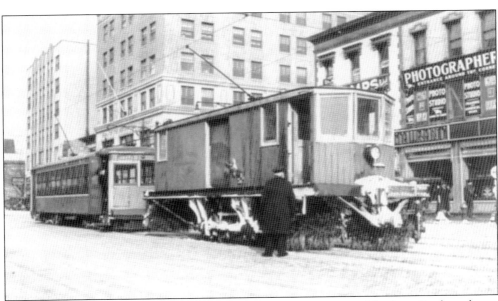

Snow sweeper No. 05 clears the way for a passenger car running on Northern Boulevard near Main Street in downtown Flushing.

The New York and Queens County Railway fielded this little beauty: car No. 1, a sprinkler car whose sole purpose in life was to spray water to keep the summer dust down on the dirt streets carrying the railway's trolley tracks.

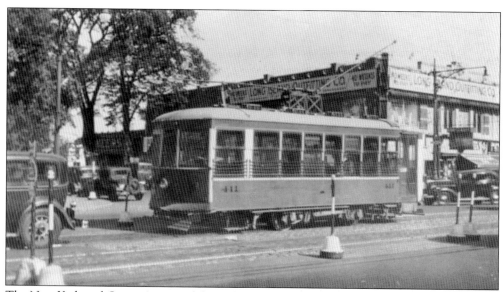

The New York and Queens's original fleet of 12 Birney cars was decimated in the 1930 carbarn fire. Only two cars, Nos. 400 and 411, were not destroyed. The New York and Queens then purchased four replacement Birneys from the Susquehanna Transit Company of Lock Haven, Pennsylvania, in 1932. Survivor car No. 411 bobbles down Main Street, Flushing, in 1936.

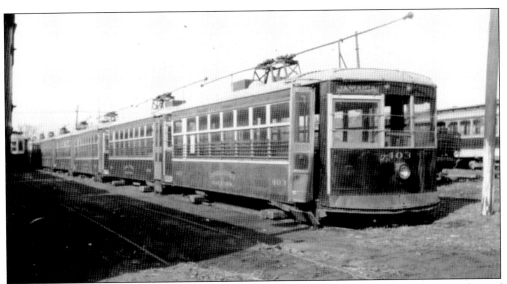

To have a ready source of spare parts, the New York and Queens bought the entire fleet of Birneys from the defunct Jamaica Central Railways. The cars were never put in service but remained in the Woodside yard, chocked up on wooden blocks.

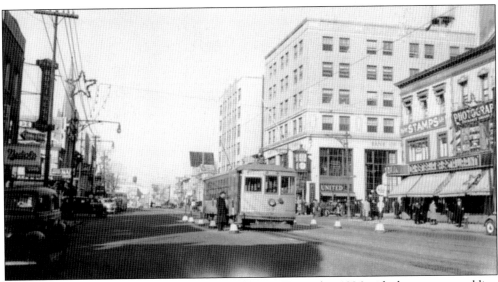

Downtown Flushing certainly looked metropolitan in December 1936 with the streetcars adding a touch of permanence. However, within a year, the trolleys were gone forever.

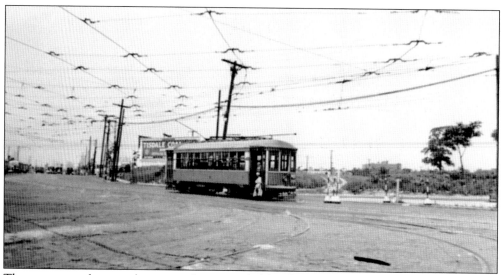

The area around any carbarn was always typified by the overwhelming supply of trolley wire powering tracks leading to the building. The Woodside barn was an excellent example of the trade. Car No. 5, a former Auburn and Syracuse Railway (Auburn) car, has just emerged from the web.

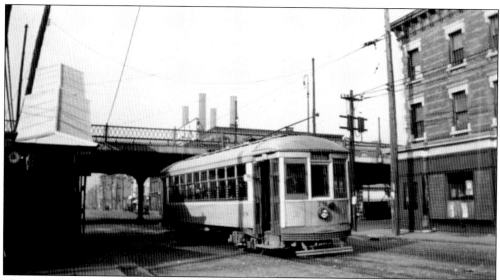

The Borden Avenue line was originally operated by sister company New York and North Shore Railway. However, during the New York and Queens County Railway reorganization, the line reverted to the new New York and Queens Railway. Car No. 19, thirdhand from the recently defunct Jamaica Central Railways, is eagerly awaiting some boarding passengers.

Two

The Manhattan and Queens Traction

Sometimes things just do not work out the way they were planned. Take the Manhattan and Queens for instance. Originally the South Shore Traction Company, it had a franchise to construct over 50 miles of street railways in Nassau and Suffolk Counties. Litigation with local communities and the competing New York and Long Island Traction Company altered things. The South Shore did construct short lines out of Patchogue and Sayville that were never connected to Nassau rails and did pick up a trolley line over the Queensborough Bridge from Manhattan to Long Island City. By 1912, South Shore had dropped its Suffolk County lines and reorganized the Queens operations as the Manhattan and Queens Traction. The new company then built eastward on Queens Boulevard, to Woodside, Elmhurst, Forest Hills, and Jamaica. It gained trackage rights on Jamaica Avenue from Brooklyn Rapid Transit's subsidiary, the Brooklyn, Queens County and Suburban, finally reaching the Long Island Rail Road's Jamaica station in 1914. A planned extension was never built except for a short track, south of the station.

The line was equipped with large, double-truck, center-door, steel, two-man cars. The cars were two motored, using maximum traction trucks, but were still able to conquer the grades around Forest Hills. To save wages, the line purchased four end-platform, double-truck one- and two-man cars from Wilmington, Delaware, just after World War I. About that time, a new short branch known as its Industrial Line was built along Van Dam Street in Long Island City.

When the main line to Jamaica was built, very few settlements existed between the villages and the line had some hard times. Fortunately, new traffic in the form of Manhattanites who moved to "the country" came along in time. As this movement accelerated, the New York City Transit Commission started planning its Independent subway system and decided that a line under Queens Boulevard to Jamaica was a priority. The line was constructed directly beneath most of the same streets that the Manhattan and Queens traversed. The upshot was that the city-operated Independent Line was deemed to be too competitive for the privately owned surface line, and in the midst of its highest passenger ridership, the trolley service was abandoned in 1937. The Industrial Line had ceased operation years before. So in the end, the Manhattan and Queens, partial successor to the South Shore Traction Company, never became the trunk-line trolley to Nassau and Suffolk but ended up as a major Queens transit artery.

In retrospect, an odd recognition is apparent. In its final form, the Manhattan and Queens had most of the characteristics of what later was known as light rail. It operated high-speed, comfortable cars through a developing territory. A majority of its route was operated on off-street rails, allowing for increased speed of its cars and safely segregating the line from automotive traffic. It built a private right-of-way under the new Corona (now Flushing) Interborough Rapid Transit elevated line along Queens Boulevard in Long Island City, the most congested area served. Farther along the line, its rails were laid either in center-of-the-road double-track segments or in single-directional rights-of-way between multidirectional automobile traffic lanes.

Today there is no sign that a heavy-duty trolley line once carried passengers on Queens Boulevard.

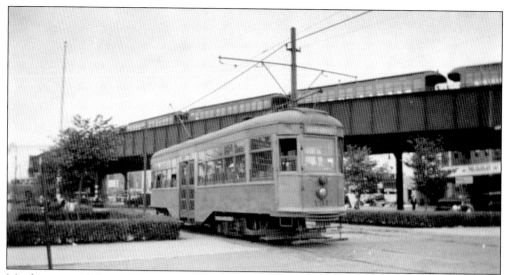

Manhattan and Queens car No. 131 emerges from under the Flushing elevated structure on Queens Boulevard in Long Island City. The trolley will swing right and pick up its own single-track private right-of-way between the lanes of automobile roadway. Note the open-platform elevated cars stored on the rapid transit tracks. Just a few years later, these tracks were polished by rapid transit trains rushing crowds to the 1939–1940 New York World's Fair.

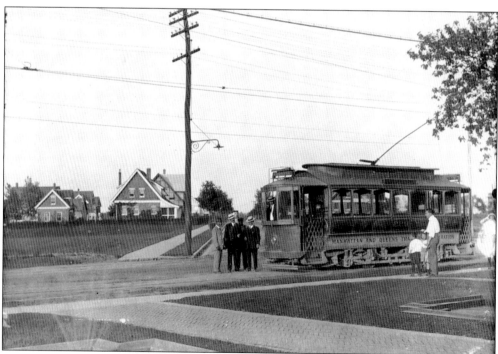

When the Manhattan and Queens started service, it initially used these secondhand cars, originally built for the Third Avenue Railroad (reorganized as the Third Avenue Railway) as cable cars. Car No. 228 was quickly replaced by more advanced, new double-truck cars.

Lightly populated Queens Boulevard hosted a Manhattan and Queens car in 1935. The view is near Grand Avenue in Elmhurst. The then under-construction competing Independent subway line's opening would shortly replace the streetcars and the rebuilding of Queens Boulevard to handle motor vehicular traffic would completely erase any signs of the Manhattan and Queens.

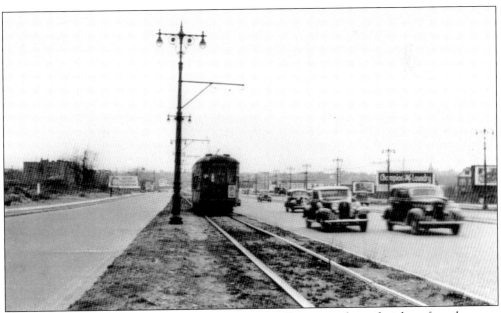

The inner portion of Queens Boulevard carried the trolleys on single-track rights-of-way between the automobile lanes.

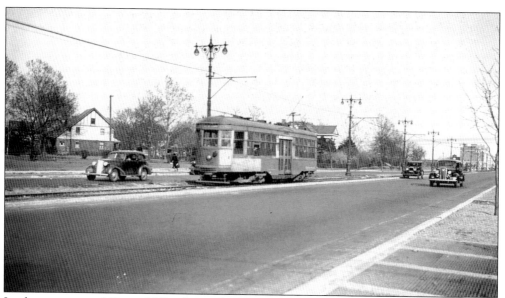

In the area around Forest Hills, the trolleys ran on a center-of-the-road reservation. This is Queens Boulevard and 72nd Street in 1937.

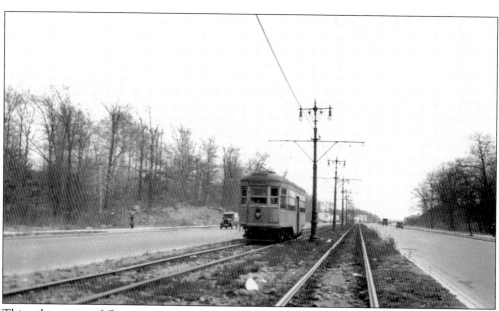

This sylvan area of Queens is now a forest of apartment houses, the trolley is long gone, and running under Queens Boulevard is the Queens line of the former Independent subway system.

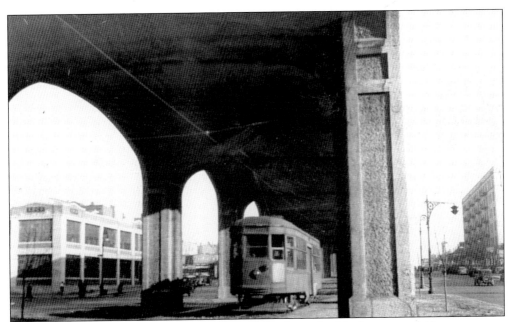

In the Long Island City–Sunnyside section of the line, the Manhattan and Queens ran on reserved track under the structure of the Flushing elevated rapid transit line. This area is now paved and used for local parking.

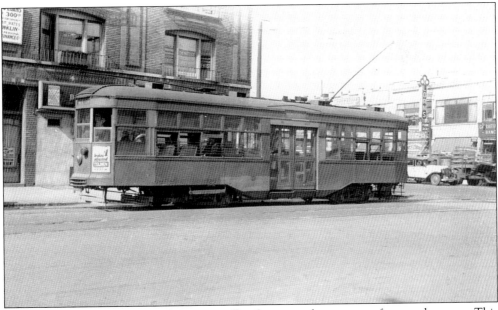

The core of the Manhattan and Queens trolley fleet was a large group of center-door cars. This specific car is at the outer end of the line at Sutphin Boulevard, Jamaica.

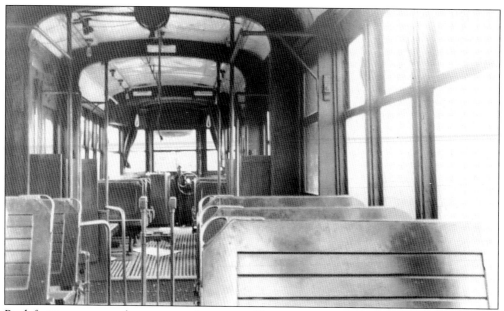

By definition, a center-door car must be operated by a two-man crew, one of whom collects the fares. The entrance to this type of car had a depressed area for quick loading and unloading and a station for the conductor's task. This is the interior of car No. 110.

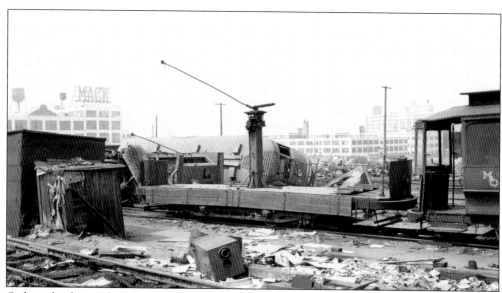

Ordinarily the work equipment of trolley companies was not particularly photogenic. The Manhattan and Queens had a diminutive single truck motorized flat car that might not have been a glamour girl (check out those sags), but certainly deserved to be immortalized on film.

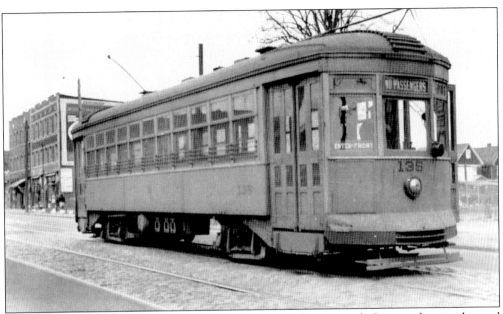

Business increased after World War I, and the Manhattan and Queens, having learned an expensive lesson, purchased four surplus cars from the Wilmington (Delaware) streetcar company. However, this time, the cars had end doors and could be operated with either a one- or two-man crew. One-man car No. 130 carries a small window sign advising passengers to "enter front," where their fares were collected by the motorman.

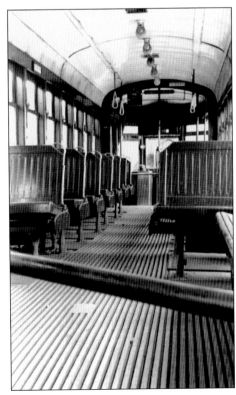

The one-man cars, although practical and efficient, were not noted for their luxurious seating. The wooden, reversible seats and minimal lighting were considered spartan at best.

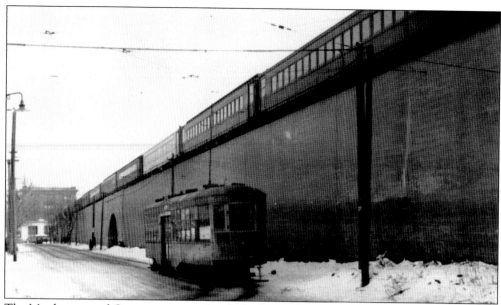

The Manhattan and Queens connected with the Long Island Rail Road's Jamaica station at the far end of this stretch of track. Quite a few of the Long Island Rail Road's passengers began or ended their rail journey on the connecting services of the Manhattan and Queens.

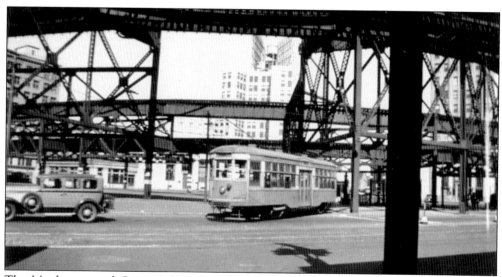

The Manhattan and Queens's line started in an underground terminal at 59th Street and Second Avenue in Manhattan. The line crossed into Queens on the Queensborough Bridge and then traversed the busy trolley-laden area of Long Island City, with the elevated junction of the Flushing and Astoria rapid transit elevated lines providing the shade.

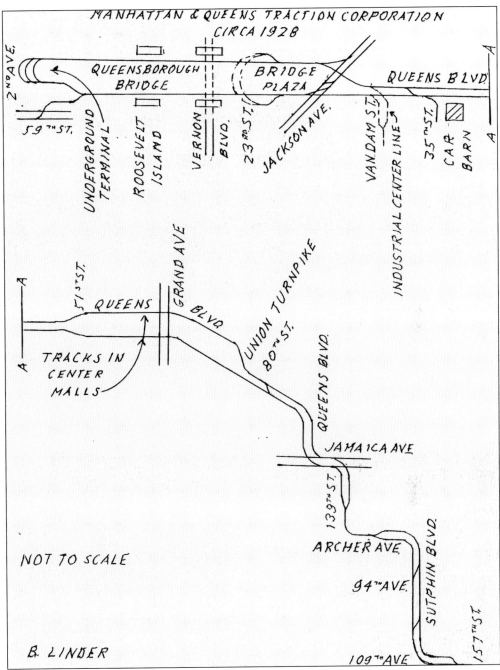

This is a track map of the Manhattan and Queens Traction Railway in 1928.

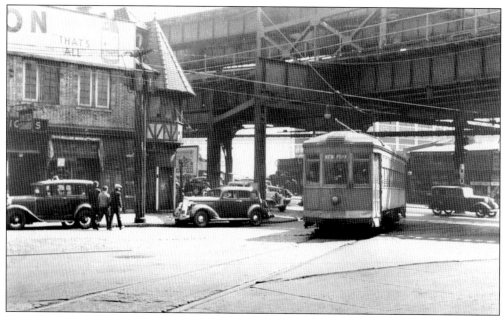

Once beyond the heavy vehicular traffic flow at Queens Plaza, the line finally reached Queens Boulevard, which it traversed all the way to Jamaica. Here a Manhattan-bound car leaves the sanctity of Queens Boulevard and scoots across Queens Plaza to position itself for the bridge run to Manhattan. Note the destination sign, which apparently differentiates between the boroughs of Queens and Manhattan by calling the latter New York.

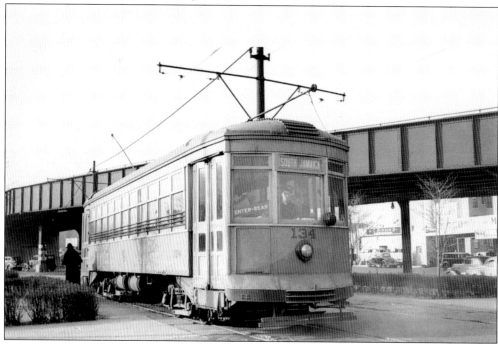

After running under the Flushing rapid transit line on reserved track, an eastbound car in two-man service halts to load a passenger before entering the private right-of-way on Queens Boulevard for the run to Jamaica.

The Manhattan and Queens had its main yard at Sunnyside, an eastern neighborhood of Long Island City. Car No. 134 stands at the entrance to the yard in 1935.

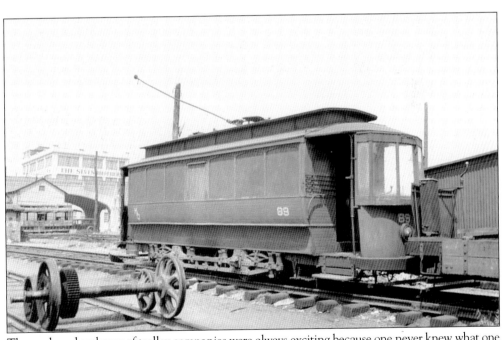

The yards and carbarns of trolley companies were always exciting because one never knew what one might see there. For instance, sand car No. 88 was possibly a passenger car on the conduit-operated New York Railways in a former life.

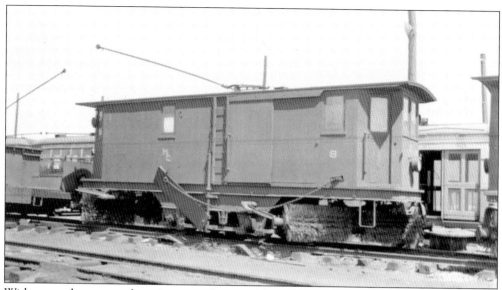

With so much open track on its run to Jamaica, the Manhattan and Queens belatedly bought snowplow No. 8 to keep the tracks open in snowy winter weather.

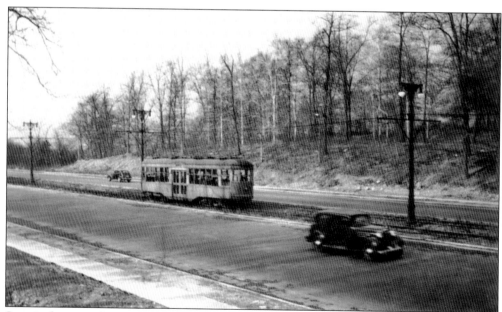

Seemingly out in the country, a Manhattan and Queens car glides along the center reservation track in the Kew Gardens area of Queens in the mid-1930s. This area is now a crowded neighborhood consisting of multiple six-story apartment houses and is completely unrecognizable from this photograph.

Three

THE NEW YORK AND NORTH SHORE TRACTION RAILWAY

One of the last and most ambitious electric railways to be built in the area was the New York and North Shore Traction Railway connecting the town of Flushing, Queens, to a large handful of important Long Island communities in the borough of Queens and Nassau County.

The system was built in three sections, the first running from Mineola to Roslyn and then to the north shore community of Port Washington on Long Island Sound. The second section ran from Mineola to Hicksville via Westbury and commenced operation in July 1907, two years after the opening of the first segment. Finally the two sectors were joined in 1910 when the connection was completed between Roslyn and the traction center of Flushing within the city limits of New York. The line was ultimately completed with a branch line to Whitestone, terminating close to the site of the present Bronx-Whitestone Bridge.

When the main line from Flushing to Hicksville was fully functioning, the run covered 24 miles and took about two hours. Unlike most of the trolley lines serving Queens and Long Island, the New York and North Shore was conceived as an interurban system and used large, railroad-roof, relatively comfortable two-man cars. These heavy cars, however, always seemed to have trouble on the long, heavy grades around Manhasset and Douglaston.

The line generated its own electricity from a large powerhouse at Douglaston, right on the water, and received its coal directly from barges serving the plant. The line's major carbarn was located at the midpoint in Roslyn. The rolling stock consisted of 19 passenger cars built by Kuhlman and Stephenson and four service cars. Although many of the passenger cars looked alike, there were some major differences between the various series. While most of the cars had platforms with single doors, many of the later cars had double doors, thereby decreasing their dwell time, unloading and loading through separate doors.

The line was not successful. The outer end never carried heavy traffic. Money was so tight that in the spring of 1920, after spending a huge amount of what little cash it had on hand cleaning up a major snowfall, the company was hit by another heavy storm. At that point, its credit was so bad the company had to borrow $10,000 to purchase coal for the powerhouse because the supplier would not extend credit.

Another facet of the poor cash situation was the "war" with the local communities, the City of New York, and the state's Public Service Commission, all of which fought to keep fares down and local taxes up.

Considering that by 1913, only three years after the line was completed, its underwriters and management regarded the entire operation as a "lemon" according to printed reports, it was a minor miracle that the line shuddered on until 1920. Out of money, the company's management offered the Queens portion of the line to the City of New York, which promptly rejected the offer. So the New York and North Shore ceased operations.

Oddly, one of the landmarks standing in the meadows around Alley Creek, Queens, was the remains of the trolley company's primitive, hand-operated A-frame drawbridge. It remained on-site until sometime after the mid-1950s, more than three decades after the line quit.

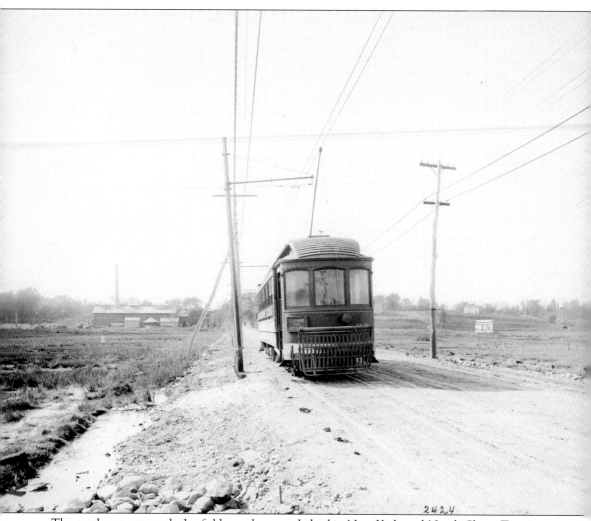

The roads are unpaved, the fields are bare, and the big New York and North Shore Traction Railway car is relatively empty. Nowadays the roads are paved, the fields are filled with suburban housing, and the trolley system is not only long gone but completely forgotten.

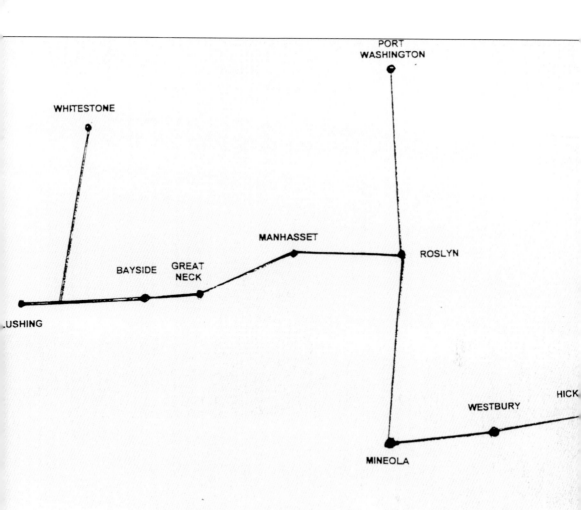

PORT
WASHINGTON

WHITESTONE

MANHASSET

ROSLYN

BAYSIDE GREAT
NECK

USHING

HICK

WESTBURY

MINEOLA

NEW YORK & NORTH SHORE TRACTION COMPANY

Shown here is the route map of the New York and North Shore around 1920. Note that although the company name implies service only along Long Island's north shore, the line also reached such mid-island destinations as Mineola, Westbury, and Hicksville.

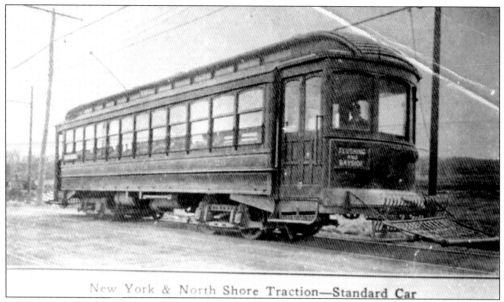

New York & North Shore Traction—Standard Car

The cars of the New York and North Shore were probably the largest and heaviest cars to be used either in Queens or Long Island. They had to be big and powerful to climb the north shore hills. This particular car is signed for an inbound trip to Flushing via Bayside.

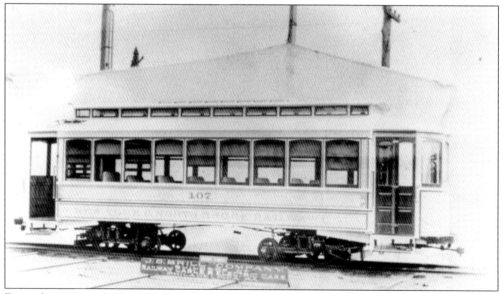

For a short time, the New York and North Shore operated the Jamaica-Flushing line of the then New York and Queens County Railway plus its Borden Avenue route. It soon discovered that these lines did not fit its operational pattern and quickly relinquished control—and shortly thereafter went into bankruptcy.

Four

THE TROLLEYS THAT
MET ALL THE TRAINS

In the 1920s and 1930s, one of America's favorite comic strips was Fontaine Fox's *The Toonerville Trolley That Met All the Trains*, featuring the Skipper, a grizzled motorman, in his somewhat decrepit trolley car and an assortment of individualistic and eccentric passengers. As the name implies, the streetcar was the connection between the railroad and the town it served.

Although Fox's trolley actually ran in New York's Westchester County, Long Island's north shore could just as well have been the site since many of its towns were away from the railroad station reached only by trolley. The topography of Long Island's north shore caused great difficulty when it came to the original building of the railroad. Because many of the towns on that shore were dependent on fishing and shipping, they were built on the coasts of the many coves, indentations, and peninsulas. If the east-west routes of the railroads were to directly serve these towns and villages, the railroad would have to have so many curves and deviations that it would not be possible to offer a viable passenger service. Some of the major towns such as Port Washington, Port Jefferson, and Oyster Bay were located at the end of a branch line, but many others were connected to their railroad stations by short one- and two-mile trolley lines whose services were directly keyed to the railroad schedules.

The Sea Cliff railroad station served twin trolley lines, the 1.55-mile Nassau County Railway connecting the village of Sea Cliff to the Long Island Rail Road while its twin, the 3.25-mile Glen Cove Railroad, served that town. Both lines were controlled by the Long Island Rail Road, and, oddly, both utilized pantograph-equipped cars using a 2,200-volt alternating current overhead system.

Huntington Village was served by the Huntington Railroad, which originally was built and also known as the Cross-Island Line, traversing central Long Island from Huntington on the north shore to Amityville on the south shore. The line was not a success and was cut back to a 7.5-mile operation connecting Huntington station to Huntington Village. It was also controlled by the Long Island Railroad. The truncated line, now called the Huntington Traction, was independently operated after the cutback. It soldiered on until 1927.

The smallest of the connecting trolley lines was the tiny Northport Traction whose 2.66 total miles joined Northport with the Long Island Rail Road's Northport station. This operation, too, was controlled by the Long Island.

By 1924, the Long Island Rail Road realized that paved roads and automobiles had rendered its connecting trolley system completely obsolete and abandoned them, leaving commuters to their own devices to travel between town and railroad depot.

The Long Island Rail Road also either operated or controlled other street railway lines within Long Island, but these lines were slightly different in scope and will be described separately.

On July 31, 1937, the Third Avenue Railway System abandoned subsidiary Westchester Electric Railroad's H-Pelham Manor route. This line, which ran between the village of Pelham Manor and the Pelham railroad station, had been the inspiration for Fontaine Fox's famous comic strip *The Toonerville Trolley That Met All the Trains*. So when the trolley operation was replaced by a bus, it was only fitting that a formal observance be held to commemorate the event. Unable to come up with a true duplicate Toonerville car, the Third Avenue Railway System dipped into its collection of single-truck passenger cars and came up with an affiliate Steinway Lines Birney as a substitute for the real thing. This photograph shows the somewhat decorated Birney and the regularly assigned convertible trolley at the Pelham railroad station plaza where the proper recognition was observed. Invited guests for the "last run" included Fontaine Fox himself and also the unnamed old codger who had served as the model for the long suffering Skipper motorman on the legendary cartoon.

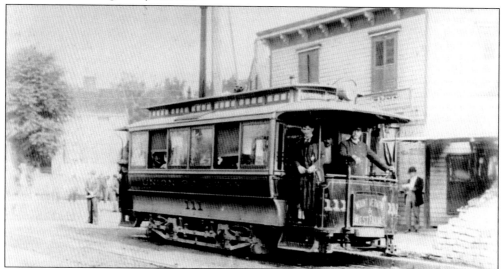

The original Toonerville trolley probably looked much like this but in worse shape. This single-truck Union Railway car actually did run in Westchester County during the time of the Toonerville.

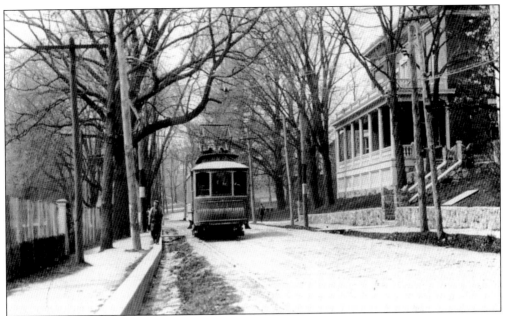

The Glen Cove Railroad was one of two lines that ran from the Sea Cliff station of the Long Island Rail Road, one connecting the station to the town of Sea Cliff and the other to the town of Glen Cove. Both lines were unique: controlled by the Long Island Rail Road and using alternating current at 2,200 volts. Here Glen Cove Railroad car No. 15 (probably), using an unusual pantograph for power connection, runs down a Glen Cove street.

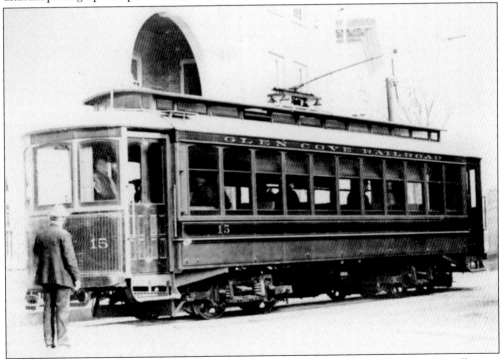

Subsequently car No. 15's pantograph was replaced by a single-trolley pole for power collection as shown in this photograph in downtown Glen Cove.

The other line from the Long Island Rail Road's Sea Cliff station was the Nassau County Railroad. Their cars originally used pantographs for power collection, as seen in this picture of the tiny but crowded open car No. 301. The use of heavy pantographs on the rather fragile roofs of open cars quickly caused structural problems to the roof of these cars, so trolley poles rapidly replaced the "pans."

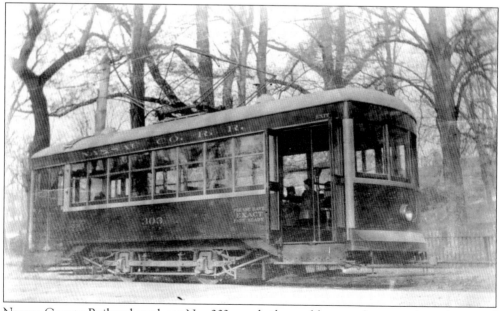

Nassau County Railroad steel car No. 303 was built sturdily enough to continue the use of pantographs on this series of cars as shown in this photograph. Both short trolley companies, owned by the Long Island Rail Road, discontinued service in 1924.

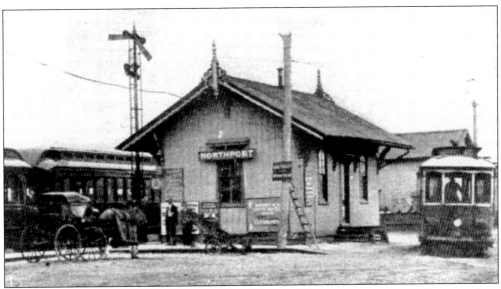

Another of the Long Island Rail Road family of short trolley operations connecting its stations to the nearby towns was the Northport Traction Company. The total mileage of this line was only 2.74 miles and was amply covered by the five streetcars operated by them. All of the cars used were from other Long Island Rail Road properties, such as the Ocean Electric Railway (Rockaway Park) or the Huntington Railroad (Huntington). The Northport Traction closed in late 1924.

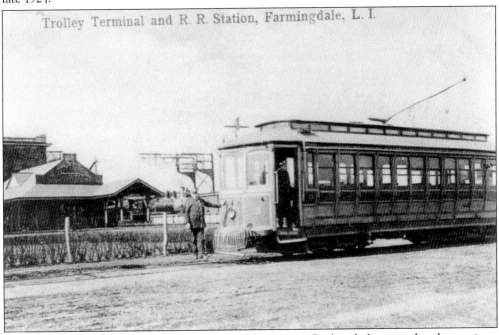

In common with the Northport Traction, the Huntington Railroad also rented and sometimes purchased trolley cars from the other major Long Island Rail Road property, the Ocean Electric Railway. Car No. 3, shown here at mid-island Farmingdale, was on lease from the Ocean Electric. Note that the car is a "convertible"—the sides can be removed in the summertime to reconfigure the car into a virtually fully open car.

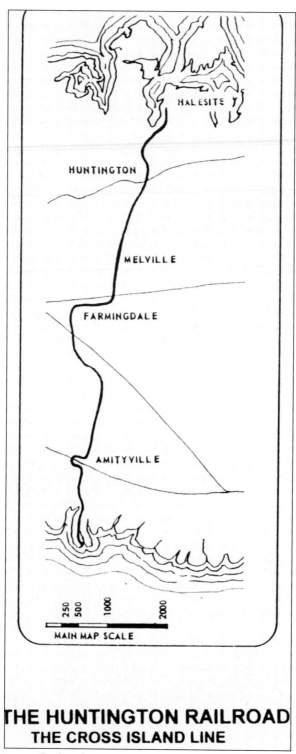

HALESITE

HUNTINGTON

MELVILLE

FARMINGDALE

AMITYVILLE

250
500
1000
2000

MAIN MAP SCALE

THE HUNTINGTON RAILROAD
THE CROSS ISLAND LINE

A map of the Huntington Railroad at its greatest operational phase is shown here. It was later cut back to the stretch between the Huntington railroad station and Halesite.

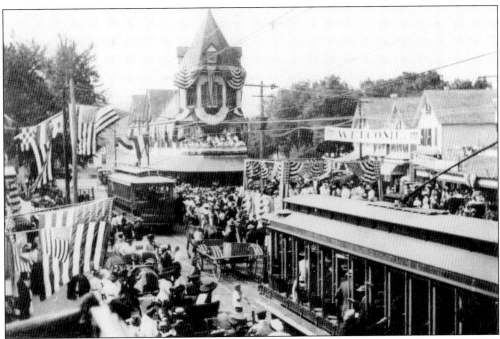

The last of the north shore communities with Long Island Rail Road–sponsored connecting trolley companies was Huntington. However, the Huntington Railroad was slightly different in that it not only ran between Huntington and Huntington station but also continued across the waist of Long Island, terminating at Amityville on the south shore. In those days, as can be seen from the following photographs, the inauguration of a trolley line was a big occasion.

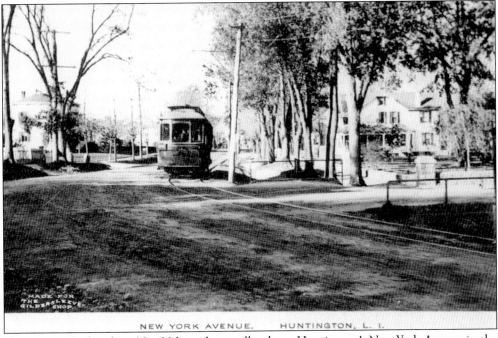

NEW YORK AVENUE. HUNTINGTON, L. I.

Huntington Railroad car No. 28 happily trundles down Huntington's New York Avenue in the traffic-free days of yesteryear.

Those halcyon early days of cross-island success on the Huntington Railroad did not last long. By September 1919, the service was temporarily discontinued but restored again in 1920. However, by this time, the Long Island Rail Road had pretty much pulled out of its stewardship and reclaimed the Huntington's cars leased from the Ocean Electric. The line soldiered on but kept cutting back service until it had been reduced to its original line between the Long Island Rail Road station and the town of Halesite. By then, the management and name had changed to the Huntington Traction. Finally in August 1927, cars like No. 4, shown here, stopped running for good.

Five

THE SOUTH SHORE LINES
AND A SURPRISE

A number of independent, small street railway companies operated on the south shore of Long Island. Many were unorthodox in either propulsion or operating philosophies.

For instance, the Babylon Railroad started horsecar service in 1871, running from the Long Island Rail Road station to the municipal waterfront and beaches. Because the destination was seasonal, the 1.53-mile single-track line ran summers only. Oddly, many early street railways followed that operating scheme, usually on lines serving beaches, cemeteries, and outdoor sporting arenas. After trying out steam and other means of power, the Babylon company electrified and expanded six miles west to Amityville, where it connected with the Huntington Railroad cross-island line. Owned by Suffolk County Railway, Babylon Railroad planned to connect to the South Shore Traction (also owned by Suffolk) but never did. The little line died in May 1920, one of the earliest trolley abandonments on Long Island.

When the Huntington Railroad completed its cross-island route to Amityville in 1909, South Shore Traction started horsecar service out of Amityville. South Shore, having given up its share in the Manhattan and Queens Traction Railway in Long Island City, was swallowed up by the Suffolk Traction Company. Suffolk Traction built a three-legged system, with one Amityville line going to Sayville, another to Patchogue and Blue Point, and a third to Holtsville. The horsepower was replaced by interim storage battery cars, which were never replaced by the intended electric equipment. The area was still primarily a summer-only market with little off-season traffic, and in the spring of 1920, the entire operation was discontinued. The tracks remained in the streets of Blue Point until well after 1950, outlasting the service by three decades.

Another beach-serving line was the Freeport Railroad, which connected the Long Island Rail Road's station with the local beaches and the ferries to Point Lookout. It lasted from 1913 to 1924.

One of the most interesting endeavors was the Long Beach Railway, with tracks that covered most of the settled areas of this narrow, sand spit beach town. To keep costs down, the company purchased gasoline buses and modified them with flanged wheels and movable pilot trucks so that they could run on the tracks. The line ran only from 1923 to the fall of 1926.

Although the Long Island Rail Road owned and/or managed many of the short trolley lines in Queens and Long Island, it operated only a single line in its own name: the very odd Meadowbrook Shuttle line. This third-rail line connected the Long Island Rail Road's main line Meadowbrook station with its Hempstead Branch's Country Life Press station. It offered services to a golf course, the U.S. Air Corps's Mitchell Field complex, and the Country Life Press printing location. For periods, the line was operated by specially equipped Ocean Electric Railway (Long Island Rail Road subsidiary) streetcars, which had originally ran on the Huntington Railroad, and later by MP-41 multiple unit cars, which had provided the first electric service on the Long Island Rail Road. (The MP-41s were identical to the first steel cars used by the Interborough Rapid Transit subway lines.) In its last days of service, the Meadowbrook line used standard Long Island Rail Road MP-54 MU electric cars.

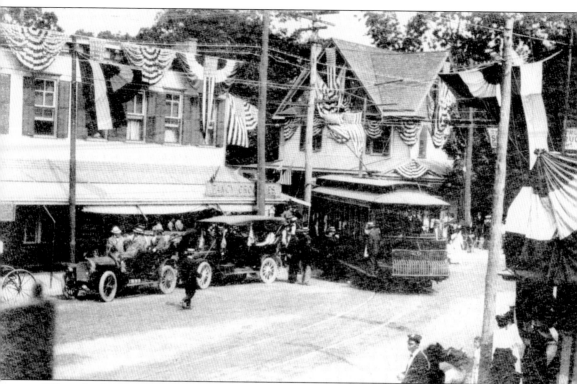

When the first revenue trolley of the Huntington Railroad's newly constructed Cross Island Line completed its inaugural trip to Amityville on August 25, 1909, it was met with great enthusiasm. But a harbinger of things to come was already in the picture—note the presence of automobiles next to the oncoming trolley.

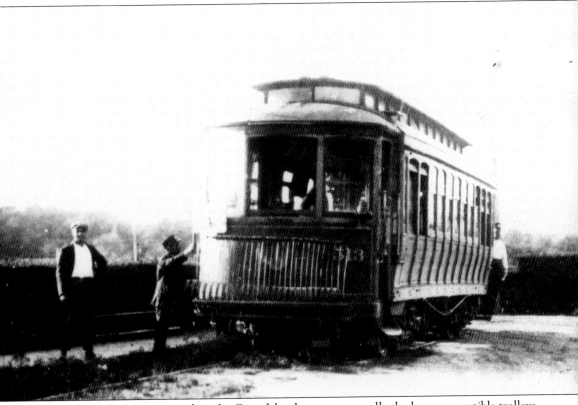

The standard equipment used on the Cross Island route was usually the large convertible trolleys owned by either the Huntington Railroad itself or leased from another Long Island Rail Road subsidiary, the Ocean Electric Railway. Convertible cars had side panels, removable for service during the long, hot Long Island summer days, "converting" the trolleys into virtual open cars.

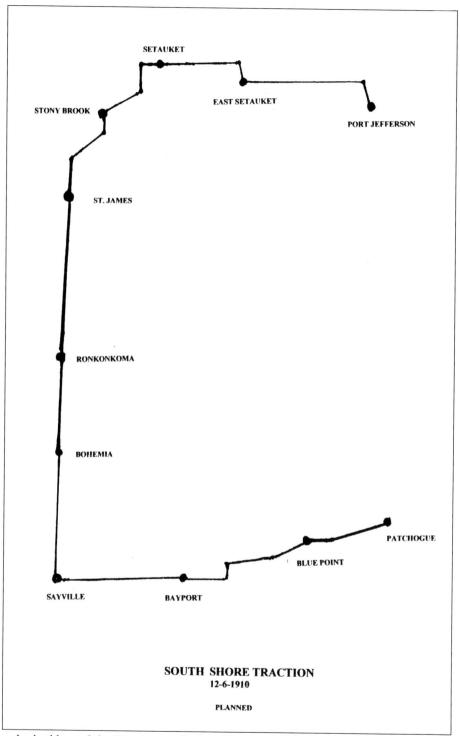

SOUTH SHORE TRACTION
12-6-1910

PLANNED

After the building of the Huntington Railroad's Cross-Island line, "trolley fever" ran rampant in eastern Long Island. Seen on these two pages are two grandiose schemes from the competing South Shore Traction and Suffolk Traction companies.

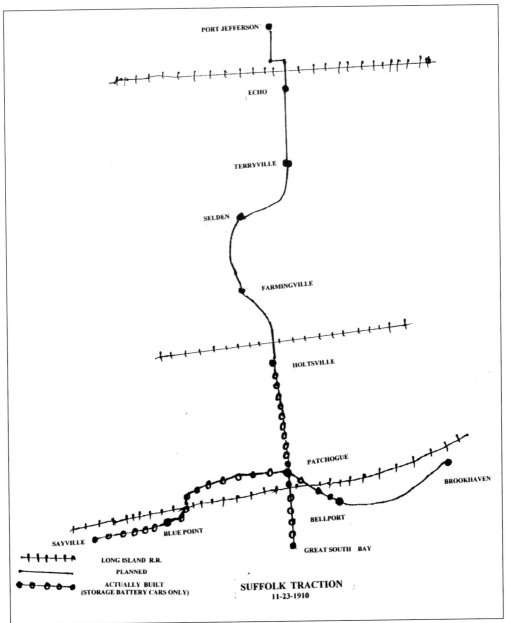

PORT JEFFERSON

ECHO

TERRYVILLE

SELDEN

FARMINGVILLE

HOLTSVILLE

PATCHOGUE

BROOKHAVEN

BELLPORT

SAYVILLE

BLUE POINT

GREAT SOUTH BAY

LONG ISLAND R.R.

PLANNED

ACTUALLY BUILT
(STORAGE BATTERY CARS ONLY)

SUFFOLK TRACTION
11-23-1910

Shortly after the proposals were made, the South Shore group sold out to the Suffolk Traction. Only the lines around the Patchogue were built using storage battery cars. The cross island portions of both proposals died aborning.

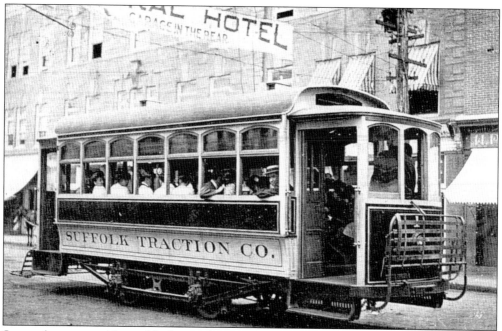

Storage battery cars like car No. 1 were the original equipment of choice on the Suffolk Traction Company. The grand plan was to electrify the lines as soon as traffic reached a sufficient level. It never did, and the battery cars lasted only as long as the company lasted. Last runs were in 1919.

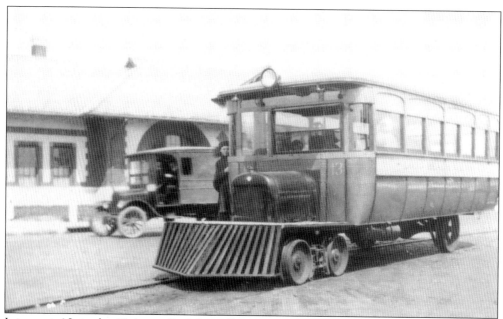

Is it a train? Is it a bus? Is it a trolley? Actually it is an early internal combustion railbus running on the ill-fated Long Beach Railway. Although the management fully intended to electrify the line for electric trolleys, the lack of passengers doomed it. After only a few years, the owners decided that their pride and joy was not attractive enough to draw sufficient passengers, and they quickly abandoned the line in 1925 after only about three years of operation.

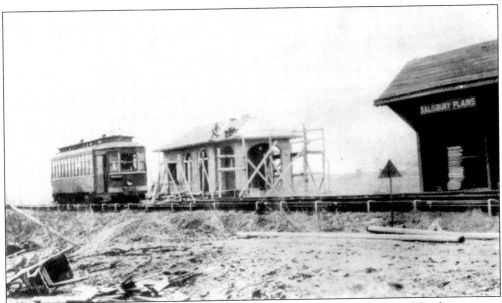

A real surprise in the central Long Island area was the Long Island Rail Road's electric train shuttle service between Garden City and Country Life Press, Meadowbrook, Salisbury Plains, and the U.S. Army Air Corps facility at Mitchell Field. The original steam-operated equipment was displaced by Huntington Railroad and Ocean Electric trolley cars, equipped for third rail operation. Long Island Rail Road car No. 15 came from the Ocean Electric and is shown at the under-construction Salisbury Plains station in 1916.

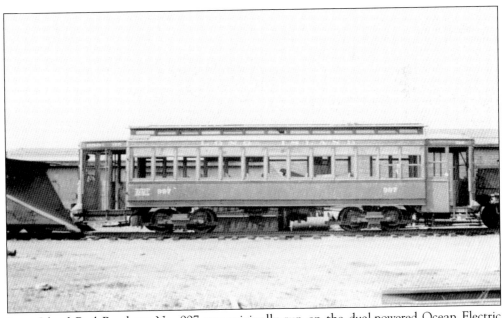

Long Island Rail Road car No. 997 was originally run on the dual-powered Ocean Electric Railway in the Rockaways. When it came to the Country Life Press shuttle, with twin sisters No. 998 and No. 999, it was converted to third rail only. This car was scrapped about 1935. The shuttle track, de-electrified, now sees very rare freight service.

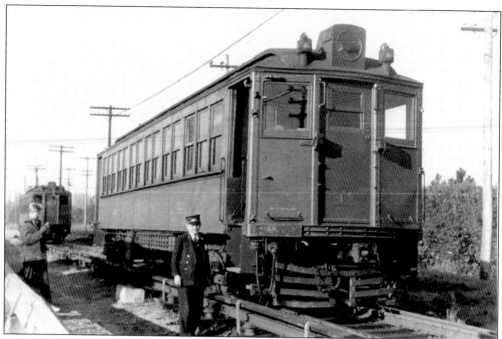

During the gasoline-rationing days of World War II, traffic increased heavily on the shuttle, and the Long Island Rail Road assigned some of its original electric cars, its MP-41s, to the line. This particular car still sports its original route-indicating marker lights.

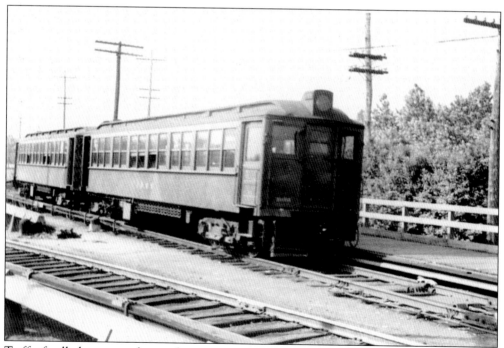

Traffic finally became so heavy that two-car trains were often used. Note the lack of marker lights on the lead car, and also note the track derailer on the left rail. These devices derailed an errant train should it wander onto active rails by mistake.

Six

The New York and Long Island Traction Company

One of the first comprehensive traction companies to reach its apogee and then die early was the New York and Long Island Traction Company. It also offered the most widespread services of any street railway in the New York metropolitan area.

The western end of the route started at one of the most concentrated areas of trolley services imaginable. Within a three-block area of Jamaica were the lines of the New York and Long Island Traction, the Long Island Electric, the Manhattan and Queens, the New York and Queens County, and the Brooklyn Rapid Transit/Brooklyn and Manhattan Transit/Brooklyn and Queens Transit streetcar and rapid transit services. The intersection of Jamaica Avenue and 160th Street (Washington Street) in Jamaica had this highly diverse conjunction of all of the above services. To sweeten the mix, at one time, Brooklyn Rapid Transit elevated trains even shared their street right-of-way with their own Jamaica Avenue streetcars.

Much of the original trackage of the New York and Long Island Traction was built by predecessor company the Mineola, Hempstead and Freeport Traction Company. After completing the construction of additional trackage, trolleys of the newly constituted New York and Long Island Traction ranged eastward from Jamaica to Nassau County destinations such as Belmont Race Track, Elmont, Bellerose, Creedmore, Floral Park, New Hyde Park, Mineola, Garden City, Hempstead, Freeport, Lynbrook, Valley Street, Baldwin, Oceanside, Rosedale, and Rockville Centre.

Its lines actually ran in a great circle with two connecting routes, one handling central Long Island and the other serving the southern section. The two divisions met at Hempstead. The company was somewhat unique in that it ran with two trolley wires, one for each direction, obviating the need for expensive overhead hardware at points where the primarily single-track lines had passing sidings.

Trolley service to Jamaica was partially on tracks owned by sister company the Long Island Electric Railway and was within the New York City limits of Queens County. The company was stymied in its efforts to raise fares by New York's almost fanatical devotion to the 5¢ fare.

Early on, the Long Island Rail Road and the Interborough Rapid Transit Company invested in the New York and Long Island Traction, considering the property to be a valuable feeder for their own operations. In fact, eventually the Long Island Rail Road supplied the power for the New York and Long Island Traction. However, in the long run, the line was perceived to be a financial failure, and after pouring much money into its operation, both the Interborough Rapid Transit Company and the Long Island Rail Road pulled out, causing the company to declare bankruptcy in February 1924. Oddly, at the time of the pullout of the two major investors, the company was earning the heaviest revenue in its history but was plagued by ineffectual and disinterested management.

The New York and Long Island Traction started abandoning line segments and by midnight of April 4, 1926, had reached such a dispirited level that all of the motormen simply deserted their cars in mid-run, effectively killing the company in one fell swoop. Many of the services were replaced by independent bus operators such as the Bee Line bus company. The abandonment of the New York and Long Island Traction was the earliest discontinuance of service of the area's major traction companies.

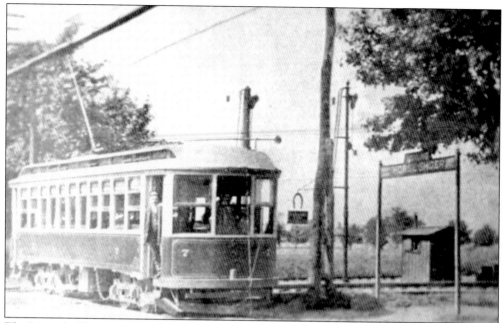

The Mineola, Hempstead and Freeport Traction Company was an early component of the New York and Long Island Traction Company, and it commenced service between and among those towns around 1900. Cars similar to No. 7 began the trolley service.

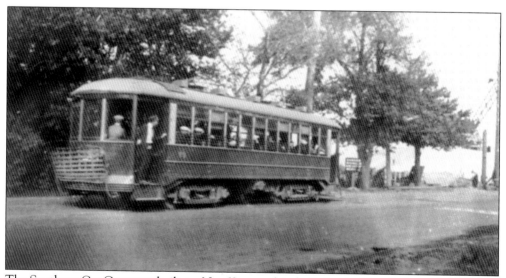

The Southern Car Company built car No. 69, one of six built for the New York and Long Island Traction in 1915. They were considered, by the trolley crews, to be the best cars ever ordered by the company. The trolley is shown entering the town of Rosedale late in the second decade of the 20th century.

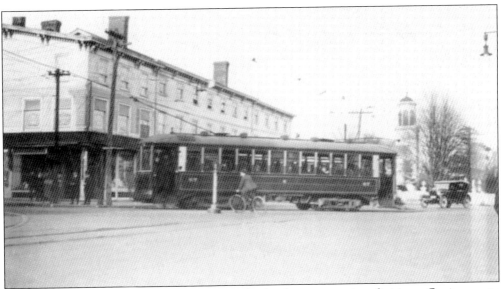

Hempstead was the junction point between the line's two operating divisions. On its way to Mineola and Garden City, car No. 69 is shown in the early 1920s passing the hotel that was the junction's station.

This hotel was the New York and Long Island's Mineola terminal. In this 1915 photograph, car No. 5 (front) has just arrived from Jamaica while car No. 45 (rear) has come from Freeport.

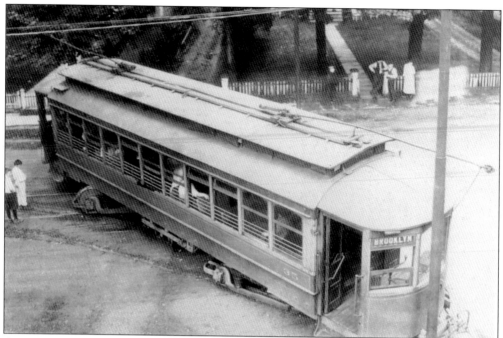

On some days, things just do not work out the way they were planned. Case in point, car No. 35 has split a switch on Front Street in Hempstead and derailed, stopping just short of hitting the utility pole carrying the electrified trolley wire.

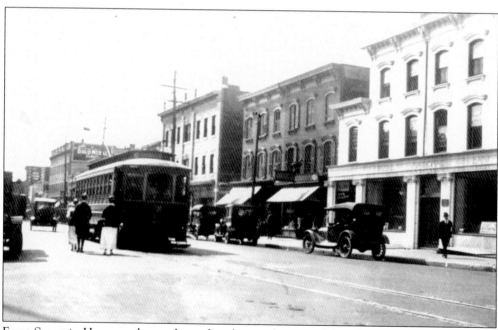

Front Street in Hempstead was a busy place late in the second decade of the 20th century. Car No. 45 loads at the terminal, which was located in the white hotel building (right, rear) on intersecting Fulton Street.

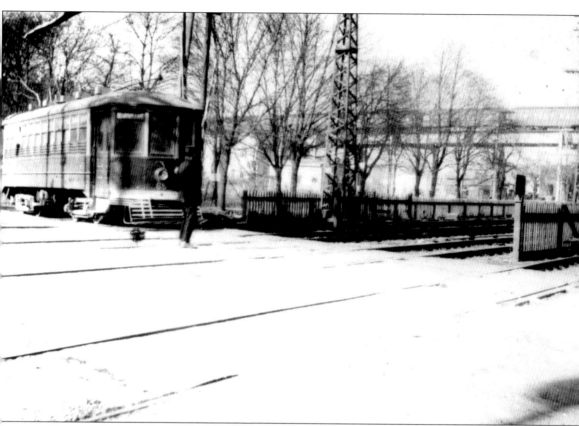

Crossing the Long Island Rail Road's tracks was always a thrill for both motormen and passengers of the New York and Long Island's trolleys. Stop, look both ways, then cross the tracks slowly so as not to dislodge the trolley pole that carries electricity to the car. Car No. 65 is shown at the crossing at Ozone Park, Queens.

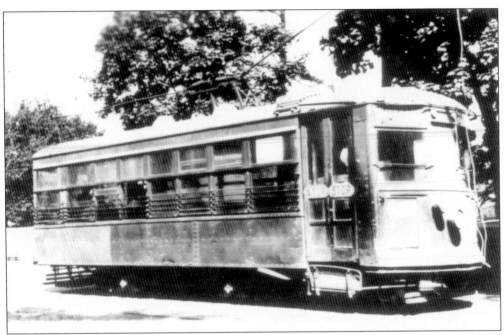

In a move to reduce operating costs, in 1920, the New York and Long Island purchased 10 secondhand, single-truck Birney cars from the Eastern Massachusetts Street Railway. Although the cars were newer than the cars they replaced, passengers felt their small size was a downsizing of the railway's service.

A New York and Long Island Traction Birney car crosses the Long Island Rail Road's electrified track at Ozone Park. These tracks were later elevated, increasing both speed and safety.

Seven

THE LONG ISLAND ELECTRIC RAILWAY

The Long Island Electric Railway was another of the trolley lines that connected the boroughs of Brooklyn and Queens to the inner suburban areas of Nassau County.

Although centered in Jamaica, the Long Island Electric also had service that originated in downtown Brooklyn and ran through Jamaica to Queens communities such as Ozone Park, Woodhaven, and Hollis, with service to the seaside community of Far Rockaway in adjoining Nassau County. Another one of its attractive destinations was the famed Belmont Park Race Track, just over the Nassau-Queens border. This line shared trackage to this point with the associated New York and Long Island Traction Company. The Long Island Electric's service area was thought to be so attractive that both the Long Island Rail Road and the Interborough Rapid Transit Company invested in it as a feeder operation.

While most of the revenue came from the prosaic suburban connecting routes, the real moneymaker was the summer operation of the long line reaching Far Rockaway's beaches. This route was served by a fleet of small single-truck open cars that carried not only heavy loads of sunburned summer passengers but also full fare boxes. Unfortunately the heavy loads were extremely destructive to the small open cars, and they were ultimately replaced by larger double-truck closed and convertible cars. As an aside, Far Rockaway actually skirted the east side of the sandy duneland abounding Jamaica Bay, which later became New York's John F. Kennedy International Airport.

Since many of the area's trolleys served rather small communities, as they grew, the roads and streets connecting those towns later required straightening and paving. Where the streetcar tracks were on the public thoroughfare, the trolley company shared in the paving costs, in effect subsidizing the competition. Another result was that the lack of drainage caused very large puddles of water on the newly paved streets often resulted in the disruption of the trolley service. One locale was such a chronic headache that it was derisively known locally as "Stansbury's Lake." Located on Jamaica Avenue between 184th and 186th Streets, the high water was so regular that the Long Island Electric rebuilt a former open car, locating its motor to its above-water flatcar platform. This unit was stationed at the edge of Stansbury's Lake and was regularly used to tow passenger cars through the high water.

The Long Island Electric's rolling stock was old, antiquated, and obsolete—the rueful laughingstock of its riders. Finally, in 1924, the company scraped together slightly over $63,000 and purchased 25 thirdhand cars built in 1898 from its current owner, New York's Second Avenue Railroad. The new owners had the cars cleaned, repainted, and relettered and then sprung them on their unsuspecting passengers. The Long Island Electric's customers were so pleased to see purportedly new equipment that the Long Island Daily News actually wrote an editorial item congratulating the streetcar company for the "new" cars.

Because of the onerous burden of New York City's inviolate policy of a transit 5¢ fare within the city limits, the company was chronically short of cash. So when two major banks holding the company's bonds called them in, it effectively put the company on a deathwatch. Strangely, waiting in the wings was an unexpected angel who would drastically change things.

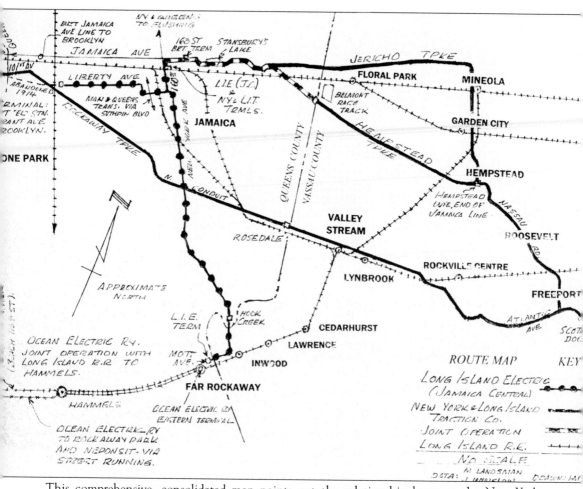

This comprehensive, consolidated map points out the relationship between the New York and Long Island Traction Company and the Long Island Electric Railway. Note the section of combined operation at the top center of the page.

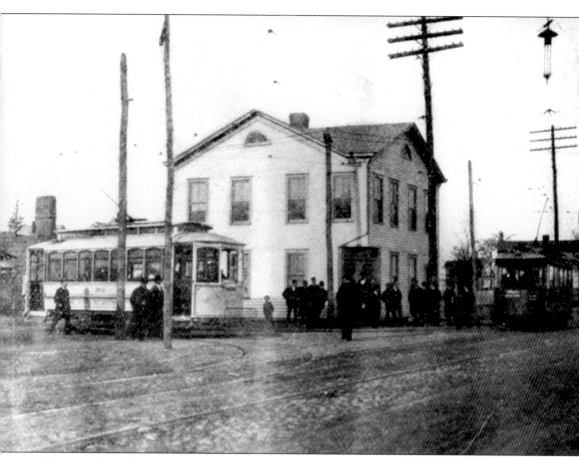

Photographs of the Long Island Electric Railway are rather hard to come by, but what is around is very quaint. Cars No. 53 and No. 17 meet at South and 160th Streets in Jamaica in 1898.

Rockaway Turnpike is strangely empty of any vehicles in this view taken in 1901 in the village of Cedarhurst. The Far Rockaway terminal of this line is just down Mott Avenue, a few blocks beyond the curve at left.

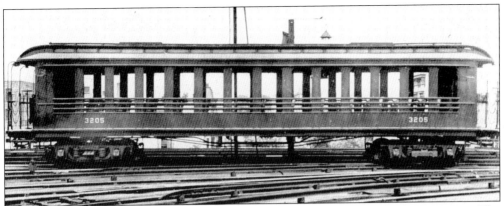

The Brooklyn Rapid Transit used these open trailers in the middle of their rapid transit trains. The ancient cars were originally used on some of the early steam-operated trains to the area's beaches.

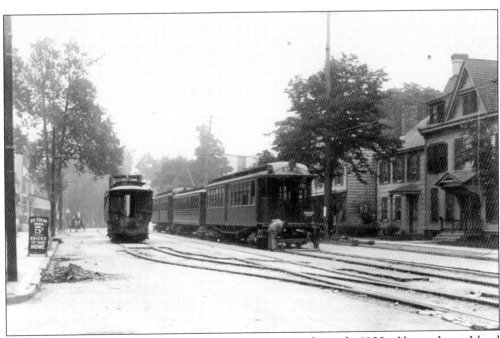

Downtown Jamaica was a center of electric traction in the early 1900s. Here a Long Island Electric line car (left) shares trackage with a Brooklyn Rapid Transit street-running rapid transit train. The Brooklyn Rapid Transit crew seems to be fussing with a "pedestrian catcher" device, designed to scoop up erring walkers who were not paying attention to the oncoming trains.

Never underestimate American ingenuity. When a lack of sewers on Jamaica Avenue in the Hollis area of Queens created a recurring flooding situation known locally as "Stanbury's Lake," the Long Island Electric's mechanical department worked out a wheeled ferry to move passengers between streetcars separated by the flood. An old work car was modified by putting the traction motors on the open deck, away from the water. Passengers rode in a motorless passenger car pulled by the motorized unit.

Eight

THE SURVIVORS
STEINWAY AND JAMAICA CENTRAL

As the trolley systems of Queens and Long Island started to disintegrate, a few properties managed to pick up some of the pieces, regroup, and start over again. Two of them are notable: the Steinway Lines, which had a short and rather unhappy second life, and the Jamaica Central Railways, which made great strides but was shot down by local politics.

As the New York and Queens County Railway was being reconstituted as the New York and Queens Railway, one of the considerations was that the original property of the Steinway Railway was to be cast adrift and once again become independent. The new company, known as the Steinway Lines, under the settlement received its routes back and a collection of virtually worn-out streetcars. Since it really had no experienced management staff, it looked around the New York City area for help, and it came in the form of the Third Avenue Railway System. The Third Avenue Railway System set up a program whereby it would operate the Steinway Lines under lease and under its own name. The Third Avenue Railway System would supply management and also lease "new" equipment to the revived line. It did not quite work out that way.

Under the somewhat less than benevolent care of the Third Avenue Railway System, Steinway suddenly started getting new, for them, rolling stock, but in reality, the Third Avenue Railway System in effect used the Steinway Lines as a dumping grounds for its own antiquated equipment. Steinway quickly received some recently converted to electricity ex-storage battery cars, which it just as quickly returned. Then the Third Avenue Railway System purchased, rehabilitated, and repainted a small fleet of obsolescent cars from the Brooklyn and Queens Transit. They too were soon removed. Finally the Third Avenue Railway System faced reality and purchased from various trolley companies a fleet of reasonably modern Birney cars for operation on the lighter lines and most of the modern double-truck cars from the recently discontinued Manhattan Bridge Three Cent Line for use on its single heavy Steinway Street line.

Unfortunately the catch basis of traffic for the Steinway Lines had mostly evaporated as many local businesses either moved or closed down. Traffic was so slight that in 1938 Steinway Lines sold its entire operation to its bondholders for a paltry $65,000. The company then started abandonment proceedings, culminating in the end of service in 1939.

Some of the newer double-truck cars were passed on to the Queensboro Bridge Railway for local service on that structure. These cars were replaced in 1949 by modern cars from the Union Street Railway of New Bedford, Massachusetts, which ran until the bridge service ended in 1958. This was the last trolley service still running in both New York City and New York State.

As the Long Island Electric Railway went through its death throes, its principal underwriter, the Chase Manhattan Bank, had some researchers who were more concerned with the future than with the past. They looked at the burgeoning population gains in eastern Queens and southwestern Nassau Counties and saw the future very clearly: the passenger base was exploding, and they were in a position to rejuvenate the ailing streetcar system and take advantage of those new markets.

So they assumed the outstanding debt and started a program to reinvent the old trolley company. First they abandoned virtually all of the trackage in Nassau County, ending up with the Long Island Electric's original core of service between Jamaica, Belmont Park, Ozone Park,

and Far Rockaway. Then they named the new company the Jamaica Central Railways and changed the livery, emulating the crimson and cream paint scheme of the well-respected Third Avenue Railway System. No more would convoys in the faded yellow of the Long Island Electric go trundling down the street, laughingly identified as the "banana line" because "the cars were yellow and came in bunches."

The Jamaica Central quickly purchased six reasonably new double-truck cars from the Empire State Railroad of Oswego and assigned them to the trunk line Jamaica Avenue line. Next a fleet of huge capacity double-truck open cars from the recently converted-to-bus New York and Stamford Railroad were bought. Although purchased by the Jamaica Central in 1926, the cars were originally built in 1911 and once assigned to the long and heavy Far Rockaway line quickly started to show their age. Their condition became so dangerous that the New York Public Service Commission ordered that the cars be removed from service at the end of the 1930 summer season. The cars were supplanted by newly purchased single-truck Birney cars from the Eastern Massachusetts Street Railway, which proved to be inadequate to the service demand. Service was reduced, the number of passengers quickly dwindled, and the route was prematurely abandoned.

On the rest of the system things were looking up. Revenues were increasing, and for the first time, some of the bonded debt was called in. The company also initiated an expensive but much needed major track rebuilding program.

However, in 1932, a new cloud appeared on the horizon of the Jamaica Central's future. The City of New York announced plans to straighten out and widen the wandering path of a major portion of Jamaica Avenue, including the section of newly relaid track. After carefully reviewing the situation, which included an alternative to again rebuild the new trackage, the Jamaica Central's management determined that that course would be folly, so rather than redo the track work, the company decided to motorize. Fortunately it had the foresight to have previously incorporated a wholly owned bus subsidiary, Jamaica Buses Inc., which ultimately inherited the reissued franchises.

On December 3, 1933, the short-lived Jamaica Central Railways ran its last streetcar. At the cessation of rail service, the company sold its former Oswego cars to the New York and Queens Railway, along with its fleet of Birneys to be used only for parts, plus some miscellaneous work equipment. And then it quietly passed out of existence.

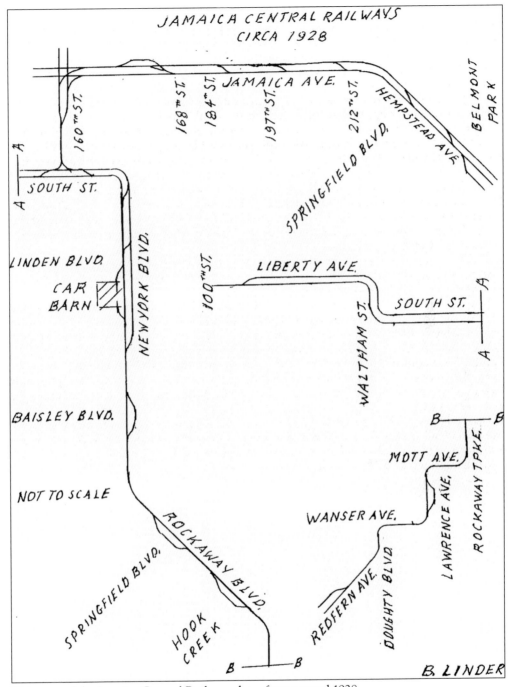

This map of the Jamaica Central Railways dates from around 1928.

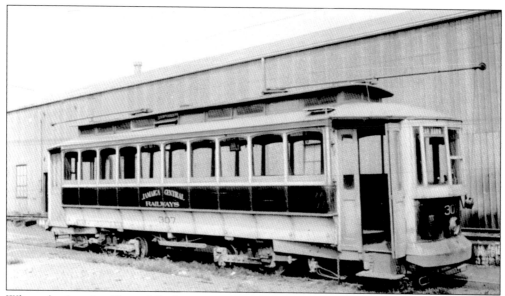

When the Jamaica Central Railways was resurrected from the wreckage of the Long Island Electric Railway in 1926, it inherited a collection of ancient rolling stock. The best equipment that it received is typified by car No. 307. This trolley car was 1 of 25 cars built between 1898 and 1902 for Manhattan's traction colossus, the Metropolitan Street Railway. When that company collapsed, it sold off these cars to the Second Avenue Railroad, which passed them on to the Long Island Electric in 1924.

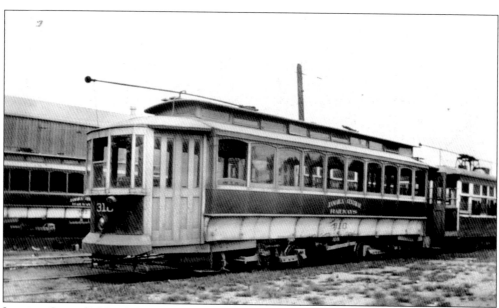

Jamaica Central's No. 310 was originally car No. 74 of the Long Island Electric. It is shown reposing in the Jamaica yard of the Jamaica Central Railways in 1933. By this time, the car was already at least 31 years old.

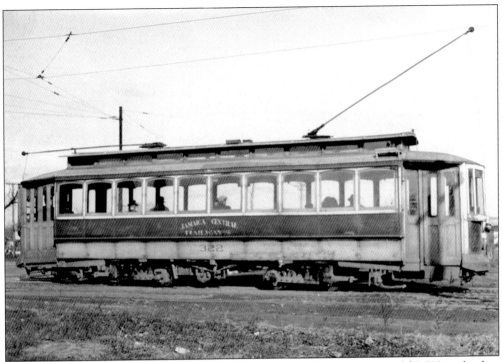

When the Long Island Electric Railway purchased these cars for a reported $2,583 each, they had to be converted from the conduit configuration of Manhattan's Second Avenue Railroad to the overhead operation that was standard in Queens and Long Island. Note that car No. 322, together with all of the other cars in this series, had only working front doors, the rear doors having been blocked for possible one-man service.

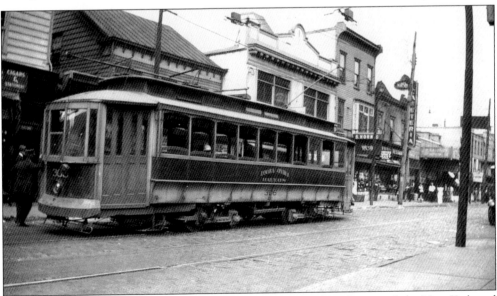

The on-street Jamaica terminal for both the Jamaica Central Railways and the New York and Queens Railway was located at Jamaica Avenue and 160th Street. Here Jamaica Central Railways car No. 306 is awaiting its call to head out to Belmont Park.

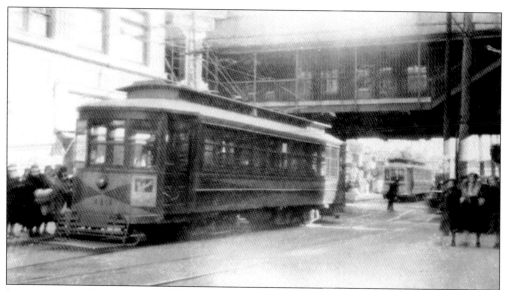

Jamaica Central Railways cars shared the 160th Street and Jamaica Avenue terminal with the New York and Queens Railway. New York and Queens car No. 312 in its new, gaudy blue and orange livery shares the street terminal with Jamaica Central Railways car No. 305 (background). In those days, vehicular traffic was reasonably light.

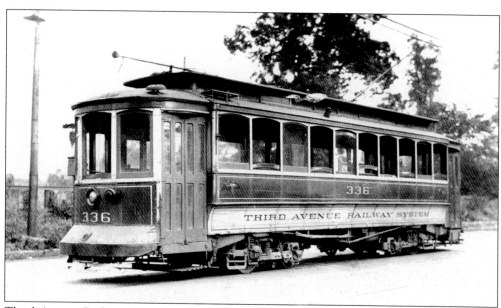

Third Avenue Railways System car No. 336 was representative of the high standards of that company. Built in 1908 by J. G. Brill for the Westchester Electric Railroad, a Third Avenue Railway System component company, the cars were later assigned to the Steinway Lines in Astoria, Queens, where they ran until sold in 1927 to the Jamaica Central Railways, where they became the new 500 series.

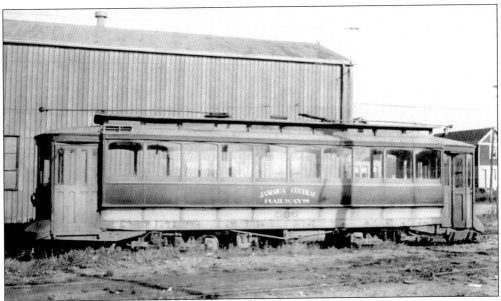

In 1927, Jamaica Central purchased six cars in the 300 series from the Third Avenue Railway System. Renumbered by the Jamaica Central Railways as No. 501 to No. 506, these cars were contemporary with the Jamaica Central Railways' own 300 series, but the cars were in remarkably good shape due to the Third Avenue Railway System's renowned car maintenance approaches.

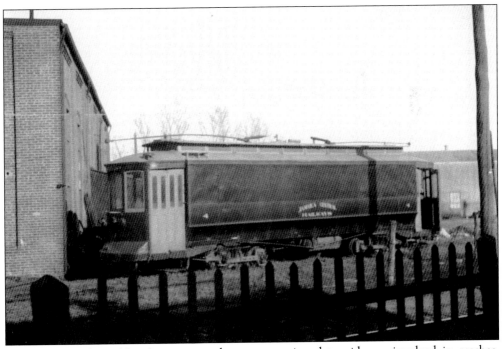

Jamaica Central car No. 4 was a wrecker, a car assigned to aid cars involved in crashes, derailments, and so forth. This particular car was rebuilt from car No. 504, one of the former Third Avenue Railway System transplants.

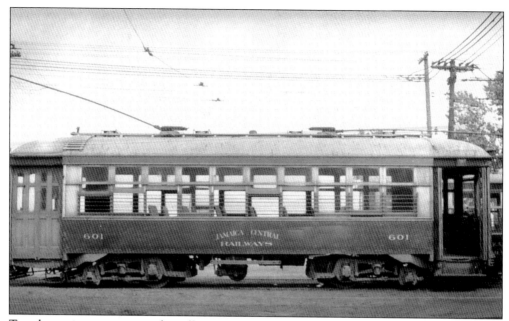

To enhance its new image and to offer a more modern streetcar to its riders, the Jamaica Central purchased, in 1927, six arched-roof, double-truck cars from the Empire State Railroad of Oswego. Car No. 601 exemplifies the "new look."

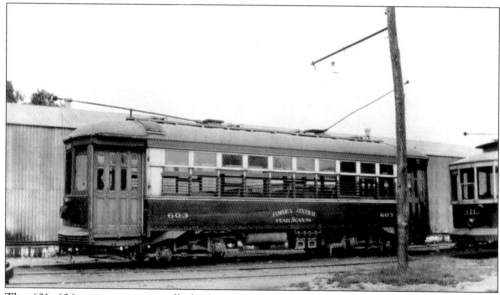

The 601–606 series was originally built in 1915 by the St. Louis Car Company. When the Jamaica Central received these cars from their original owners in 1927, it carefully renovated the cars, which became the most modern equipment that the line ever operated. Car No. 603 is shown at the Jamaica carbarn in 1933.

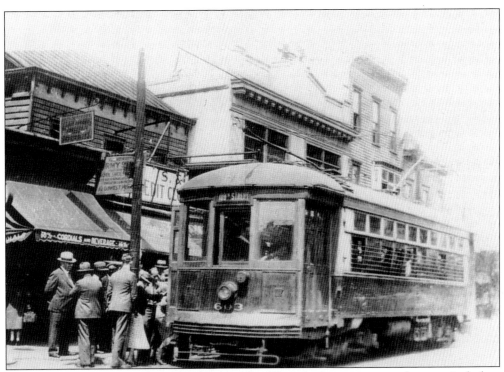

If the crowd of passengers shown loading car No. 603 at the Jamaica terminal was typical, then the 600 series must have been a success.

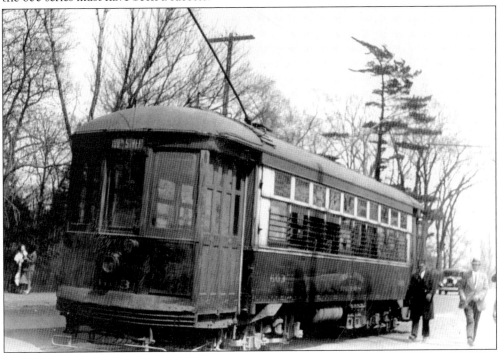

Jamaica Central's car No. 603 looks spic-and-span in this car study. Note that there are no rear steps, so these cars loaded and unloaded only via the double front door.

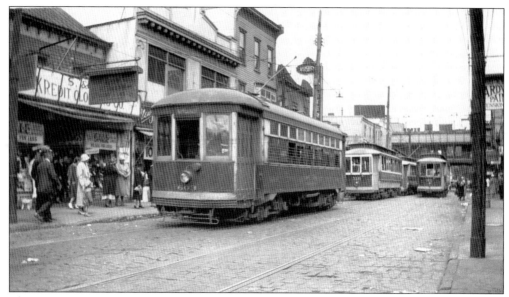

The Jamaica terminal, although in the middle of the street, was a very busy spot in June 1933. Jamaica Central cars No. 603, 318, and 303 are lined up discharging passengers, most of whom will climb to the elevated rapid transit station in the background and continue their ride to Manhattan.

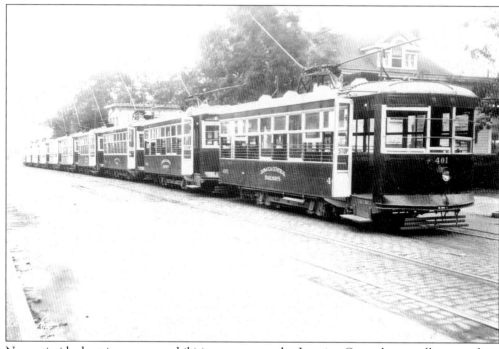

Never timid when it came to exhibiting new cars, the Jamaica Central went all out to show off its entire fleet of 10 recently purchased single-truck Birney cars. Designed to be operated inexpensively by one man, these cars enabled the Jamaica Central Railways to offer shorter headways on some of its lighter lines.

Birney car No. 406 was newly acquired from the Eastern Massachusetts Street Railway when this 1926 photograph was snapped in the Jamaica Central's Jamaica yard. The addition of the newer cars made a major change in the public image of the Jamaica Central Railways.

Street railways were famous for never throwing anything away. For instance, Jamaica Central's car No. 6 is shown in service as a sand car, bringing sand to the carbarn to be loaded in the passenger cars and used to drop on icy rails for gain traction. It was obviously originally a single-truck passenger car before conversion.

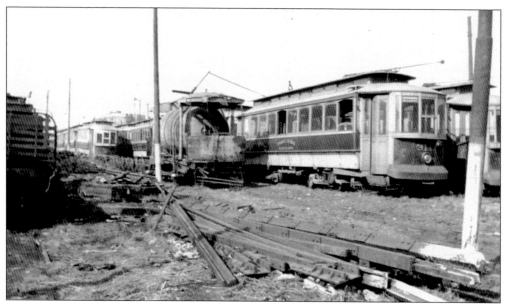

In the early days before streets were paved, as part of their franchise requirements, street railways had the obligation of sprinkling water on the streets traversed by their cars to keep the dust down. Obviously now derelict, Jamaica Central's sprinkler No. 231 sits in the Woodside yard after the line had closed, awaiting its ultimate fate, namely scrapping.

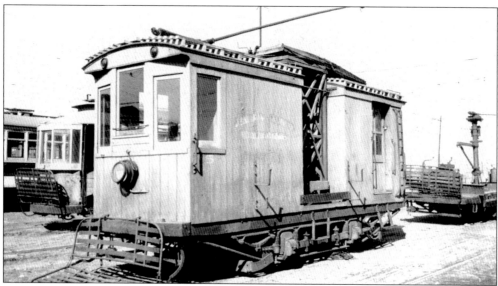

Attractive? No. But Jamaica Central line car No. 5 was of inestimable value for quickly repairing downed trolley wire. Neighbors along the line were understandably unhappy when a trolley wire carrying 600 volts of electricity was lying loose in the street in front of their houses, so the appearance of this ungainly car gladdened their eyes.

Single-truck open flatcar No. 1 was, to use a coy phrase, rather cute. Rebuilt from a former open car, it was used to carry company material around the system.

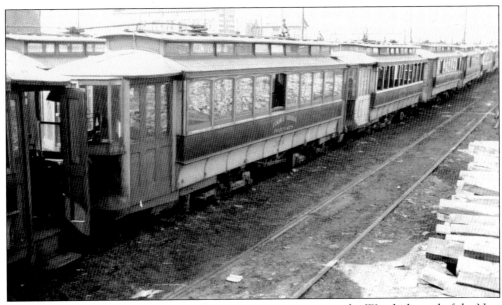

A line of derelict Jamaica Central Railways passenger cars sits in the Woodside yard of the New York and Queens Railway, awaiting their fate. These cars had originally been owned in turn by New York's Metropolitan Street Railway, the Second Avenue Railroad, and finally the Long Island Electric Railway, before ending up on the Jamaica Central's lines.

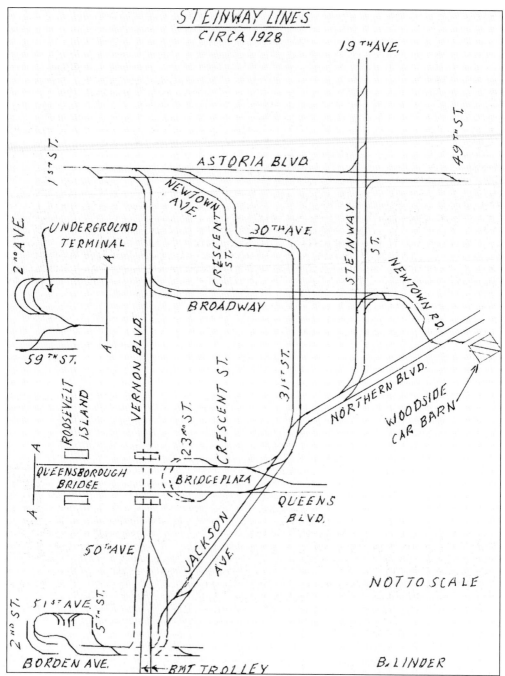

This comprehensive track map of the Steinway Lines dates from around 1928.

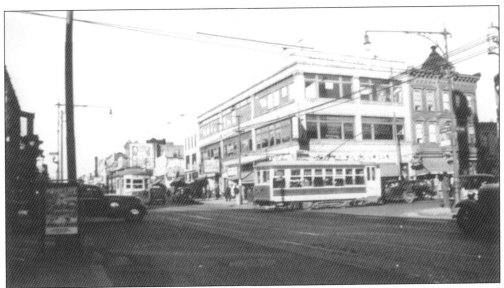

The heart of Astoria's Steinway neighborhood was the intersection of Steinway Street and Broadway. A leased Third Avenue Railway System convertible holds down a run on the Steinway Street line while a Birney in Broadway service bounces its way across the diamond.

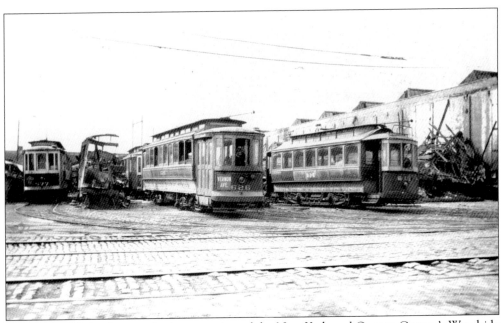

The June 1930 fire destroyed a large portion of the New York and Queens County's Woodside carbarn, which also served Steinway Lines cars. A day after the fire, a collection of survivors faces the future. A 600-series car is next to the hulk of former Manhattan Bridge Three Cent Line car. Trolley No. 626, signed for the Vernon Avenue line, was unscathed as was, surprising discovery, wrecking car No. 50, still lettered for former owner New York City Interborough.

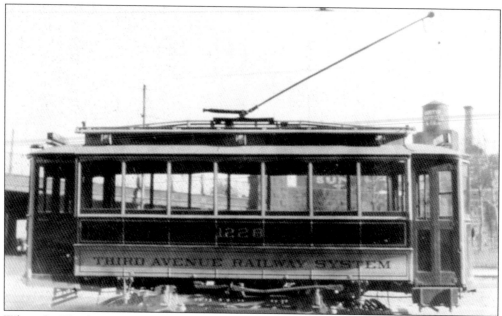

When the Third Avenue Railway System took over the operation of the Steinway Lines, it also supplied rolling stock to the trolley-poor company. Among the first cars transferred was a small fleet of newly electrified, single-truck former storage battery cars including car No. 1228. As quickly as they were delivered, they were returned as being unsuitable for service in Queens.

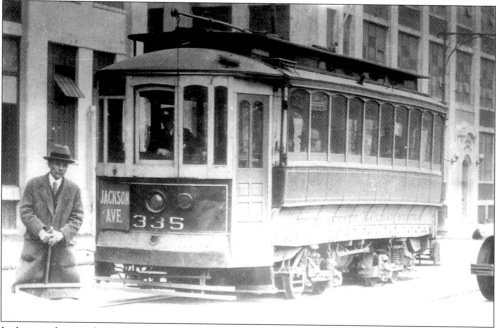

In line with its policy of "dumping" elderly equipment on Steinway, the Third Avenue Railway System in 1923 fobbed off on it 20 cars in the 331–350 series, originally built in 1908 for subsidiary Westchester Electric. These cars were replaced by former Brooklyn cars in 1927.

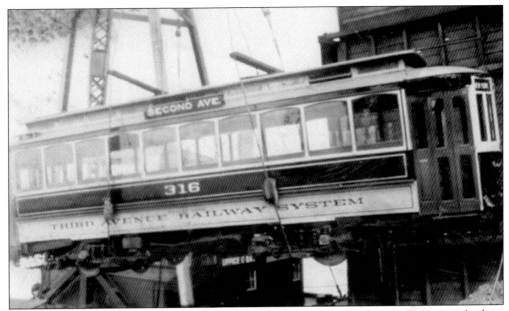

Another set of redundant Third Avenue Railway System cars was the 301–316 group, built in the 1900–1905 period and which originally ran on the Metropolitan Street Railway Manhattan conduit lines. Inherited by the Third Avenue Railway System in 1908, they were rebuilt for overhead operation and then transferred to Yonkers Railroad and to the Westchester Electric Railroad lines. Steinway got them in 1922–1923 and either retired them or sold them by 1927. Car No. 316 is shown being loaded on a barge at the Third Avenue Railway System Kingsbridge yard to be floated across the East River to Steinway's rail.

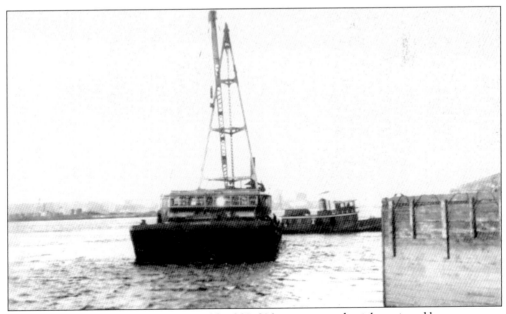

A set of Third Avenue Railway System No. 301–316 cars sit on a derrick-equipped barge en route to ultimate Steinway service in 1923.

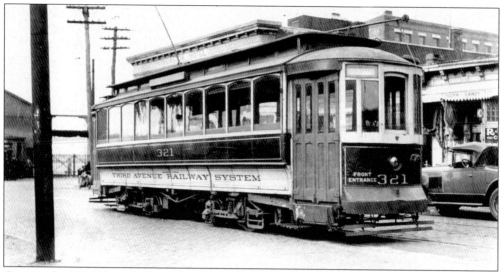

Cars in the 317–321 and 323–328 series and car No. 330 were built for the New York City Interborough in 1906 and later added to the Third Avenue Railway System fleet when the Interborough was purchased by it in 1921. They were sent to Steinway in the period between 1923 and 1926. They did not last long and were replaced by the newly acquired Brooklyn cars in 1927. Car No. 321, at the Astoria ferry terminal, shows the prefix "leased from" just over the Third Avenue name.

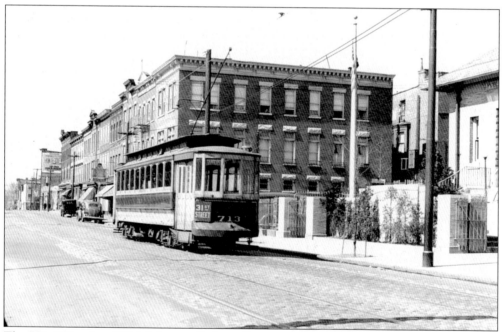

The 701–850 series of Third Avenue Railway System cars was one of its most versatile designs. These cars were used in Manhattan conduit service, throughout the Bronx in trunk line operations, and on Westchester Railroad lines around New Rochelle. Therefore, it was no surprise to find a baker's dozen in operation on the Steinway Lines, where they ran from 1937 until the end of rail service in the fall of 1939.

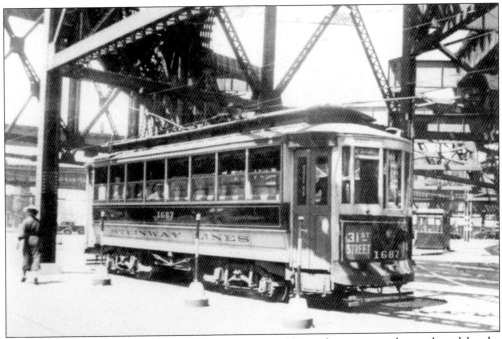

Next to be delivered was a contingent of small double-truck cars recently purchased by the Third Avenue Railway System in 1926 from the Nassau Electric, a component company of the Brooklyn and Queens Transit family. The cars were built in 1899 and were reluctantly used on Steinway routes until mostly replaced by Birney cars by the early 1930s. Originally numbered in the 301–330 series, renumbered car No. 1687 threads its way under the elevated rapid transit complex at Queens Plaza, Long Island City, in 1934.

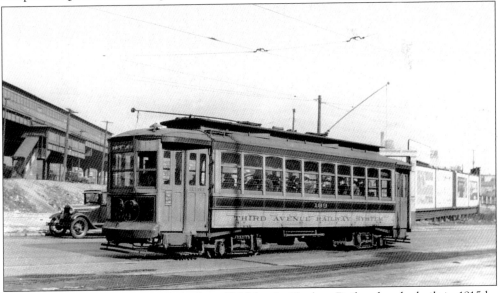

Cars No. 176–200 were originally built in 1906 for the Yonkers Railroad and rebuilt in 1915 by the Third Avenue Railway System. In 1931, the series was turned over to the Steinway Lines, where they operated until 1934. Car No. 189 is shown at Northern Boulevard and 31st Street in 1934.

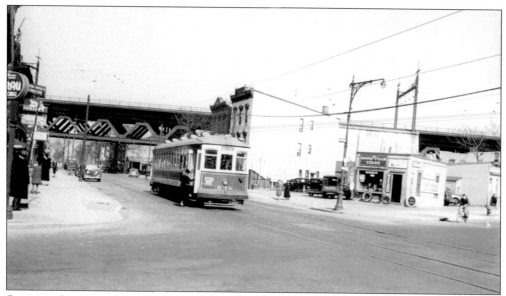

Steinway Street was Astoria's main thoroughfare, and so it was that the largest cars of the Steinway Lines traveled that street. En route to Long Island City, car No. 536 has just passed under the heavy structure of the Hell Gate Bridge.

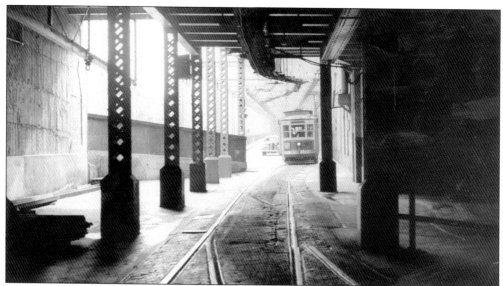

The Third Avenue Railway System's most recognized cars were its doughty convertibles used all over its system. Various examples of the former conduit-operated cars were assigned to Steinway from the very beginning of the Third Avenue Railway System stewardship in 1922. Car No. 1 is shown in Steinway Lines service entering the 59th Street Manhattan terminal of the Queensborough Bridge.

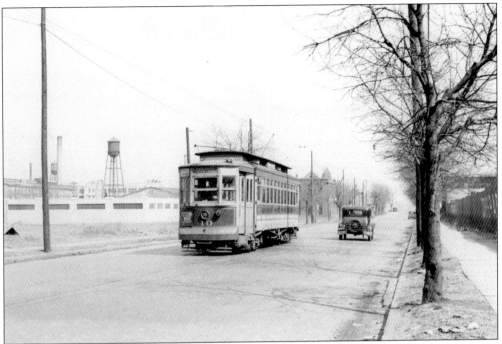

Third Avenue Railway System convertible No. 10 is holding down a run on the namesake Steinway Street line in May 1938.

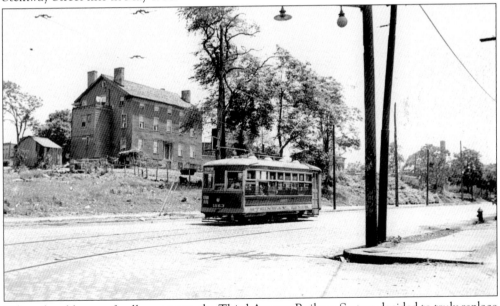

When the older cars finally wore out, the Third Avenue Railway System decided to truly replace the traditional ancient cars it had operated since the 1922 start of its operating contract with the Steinway Lines. It replaced most of the cars on the lighter lines with single-truck Birney cars such as No. 1663, shown operating on the Vernon Boulevard line. This car originally operated on the Williamsburg Bridge line of the New York City Department of Plant and Structures, was sold to the Fishkill Electric Railway of Beacon, and finally came back to New York City with twin No. 1662 in 1930.

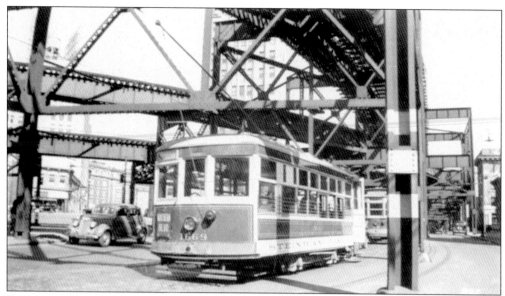

Birney car No. 1669, running on Steinway Lines's Northern Boulevard route, is traversing the complex of tracks under the Queens Plaza rapid transit elevated station. This car, with five siblings, originally ran on the Muskegon (Michigan) Traction and Lighting lines and was purchased in 1929.

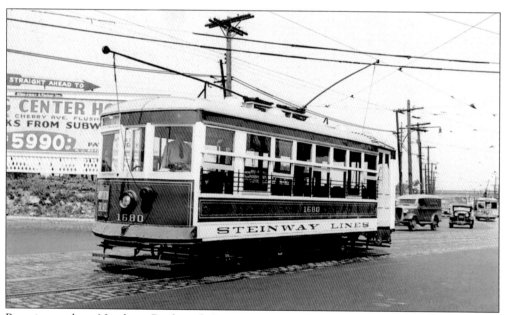

Running on busy Northern Boulevard, Steinway car No. 1680 was purchased in 1932 from the Trenton (New Jersey) and Mercer County Traction. Note the New York and Queens Birney car in the right background. This line ended service in 1938.

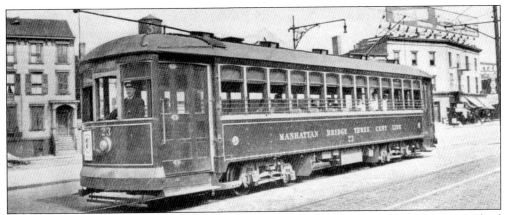

The Manhattan Bridge Three Cent Line quit running in 1929. Car No. 23 was sold to the Third Avenue Railway System in 1930 to be used on the Steinway Lines. A total of 16 cars in this series were transferred to Queens. This car became Steinway's No. 537.

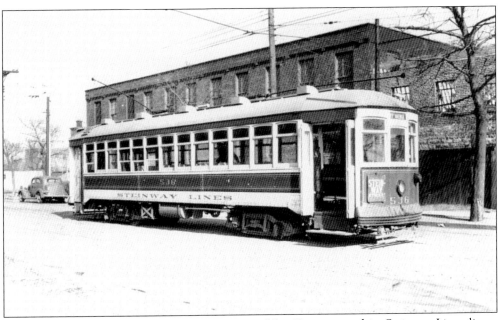

Former Manhattan Bridge Three Cent Line car No. 42 is pictured in Steinway Lines livery as car No. 536. This particular unit was renumbered 522 and transferred to the newly created Queensboro Bridge Railway.

Steinway Lines double-truck car of the 529–544 series is in service on the Steinway Street line at Northern Boulevard in January 1939. By November 1939, the entire Steinway Lines operation was only a memory.

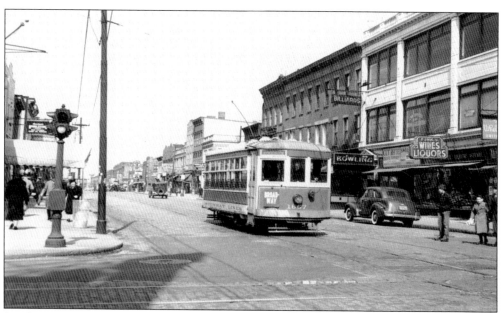

Single-truck Birney car No. 1667 originally cruised the streets of Muskegon, Michigan, before it finally found a home on the Steinway Lines. It is shown here in service on the Broadway line approaching the rails of the intersecting Steinway Street route.

Nine

THE SAGA OF THE ROCKAWAYS

The Rockaway peninsula, essentially a long, narrow sand spit, runs roughly from Far Rockaway through the communities of Hammels and Holland to the community of Rockaway Park. Then it continues westward via Belle Harbor to Neponsit, ending at Jacob Riis Park. At present, it is all considered a part of metropolitan New York City and is all contained within the city limits in the borough of Queens. Once primarily a seashore resort area, it is now in the process of becoming a bedroom community for New Yorkers. This very short synopsis does not begin to give the reader a hint of how the area collectively called the Rockaways was once the center of some of the most interesting electric railroading in the metropolitan area.

One of the earliest operations was the Rockaway Village Railroad, which was built as a horsecar line in 1886 and electrified by the Long Island Rail Road's subsidiary Ocean Electric Railway and abandoned in 1924. It was only about a mile long and connected the railroad to the center of Far Rockaway.

A Queens County's suburban line, the Long Island Electric, ran a trolley service from Jamaica via a long, slow line across the Jamaica Bay swamps and meadows, terminating a short distance from the Far Rockaway station of the Long Island Rail Road. When the Long Island Electric fell on hard times and was reorganized, the successor company, the Jamaica Central Railways, continued this service. Recognizing the value of the summer beach traffic, in 1926 the Jamaica Central invested in a fleet of huge double-truck open cars from the recently discontinued New York and Stamford line. The cars were a great success, but after only a few years of hard service to Far Rockaway, the cars wore out, and their use was discontinued in the fall of 1930. The loss of their revenue was a major contributing factor both to the discontinuance of the Far Rockaway service and the early demise in 1933 of the entire street railway.

The Long Island Rail Road was the major rail carrier in that area. It ran from both the Flatbush Avenue terminal in Brooklyn and from Long Island City and later Manhattan's Pennsylvania Station to Far Rockaway and Rockaway Park, offering early electrified services. Its Far Rockaway service was most unusual in that trains could come via Valley Stream on the Atlantic Branch or via Jamaica Bay on the Rockaway Beach branch. In some cases, Far Rockaway trains used both routes, making a circle voyage locally called "going around the horn" and confusing railroad buffs who had never ridden that routing.

Service to Rockaway Park was from Pennsylvania Station or from Brooklyn using the Atlantic Avenue line via Ozone Park, reaching the beach resort by means of the series of wooden trestles across Jamaica Bay through such intermediate stations as Broad Channel and the Raunt. The latter point was a tiny establishment mainly built on pilings in Jamaica Bay and reached only by rail or boat. Popular legend has it that the community lost most of its revenue when Prohibition ended, and the number of nocturnally operated, fast speedboats dramatically decreased.

When the trains across Jamaica Bay reached Hammels Junction on the narrow Rockaway peninsula, they either turned left and went east to Far Rockaway or turned right and terminated at Beach 116th Street, the main street of Rockaway Park. Local service between Rockaway Park and Far Rockaway was offered by the Ocean Electric Railway, a Long Island Rail Road–sponsored trolley line that ultimately ran from Neponsit, a far west neighborhood of Rockaway Park, to Far Rockaway station. Within Rockaway Park, the Ocean Electric mostly used city streets. Rockaway Beach Boulevard was really the only street wide enough to carry streetcars, but at Hammels, the line veered over to and joined the Far Rockaway–bound branch of the Long Island Rail Road. Originally the Ocean Electric cars used overhead wire on that part of the voyage but later

decided to equip its cars with third rail shoes plus trolley poles and used the Long Island Rail Road's source of electricity. It was one of the very few operations in New York State where main line trains and trolleys operated simultaneously on the same tracks.

By 1928, vehicular traffic was so severe on the narrow Rockaway Park end of the line that it became apparent that the New York Public Service Commission would not permit a renewal of the Ocean Electric's franchise. On September 26, at the height of the trolley line's popularity, the last trolleys ran.

For many years, the Long Island Rail Road ran both the Jamaica Bay and Valley Stream routes, but in May 1950, there was a disastrous fire on the Jamaica Bay trestles that severed that route completely. The Jamaica Bay line lay dormant for several years with both Rockaway Park and Far Rockaway trains going via Valley Stream while the New York City Board of Transportation and the Long Island Rail Road discussed the probability of New York City buying the Jamaica Bay line, which was entirely within the city limits. And on June 11, 1952, it was purchased together with the short stretch of track that went east from Hammels to the Mott Avenue station in Far Rockaway, literally a stone's throw from the city's border. The Long Island Rail Road then discontinued Rockaway Park service on October 2, 1955. A new rapid transit line was constructed, connecting the New York City Transit Authority's A line with both Rockaway Park and Far Rockaway. The Long Island Rail Road continues to run from a new station in Far Rockaway to New York via the Valley Stream connection, while the subway carries seaside commuters to New York City via the Jamaica Bay line.

As a final commentary, commuters going to downtown Manhattan from Rockaway Park via subway now face a journey that takes 50 percent longer than when they rode the Long Island Rail Road.

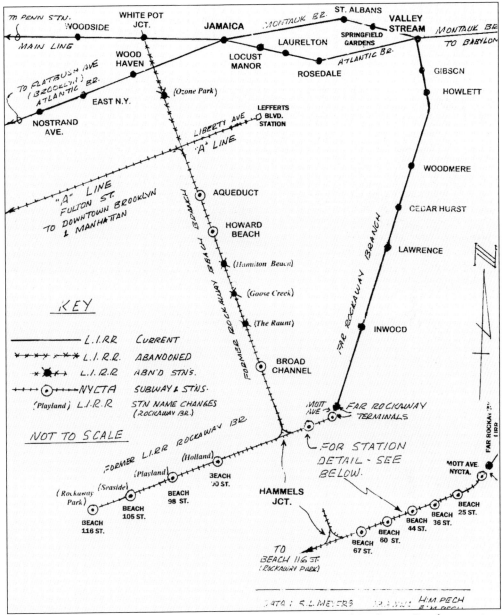

This map of the Rockaways shows the old Long Island Rail Road Rockaway Beach operation, the former Far Rockaway Division, and the new New York City Transit Authority operation that replaced them.

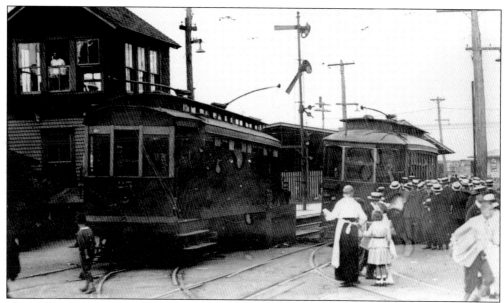

Ocean Electric cars shared the third rail electrified right-of-way of the Long Island Rail Road between Far Rockaway and Hammels. The continuation of the line to Rockaway Park was via street running, and the cars used overhead wire for that portion. Here Ocean Electric–rebuilt ex–open car No. 25 heads toward the street track while a closed car with its trolley poles down starts its third rail run to Far Rockaway.

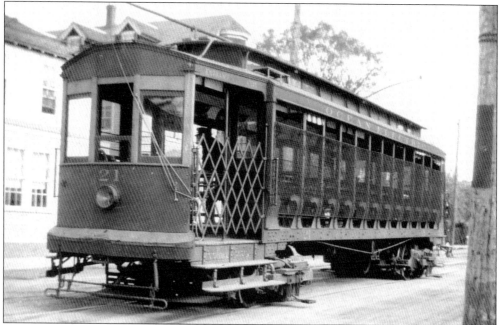

When Ocean Electric converted its fully open cars to an enclosed configuration, it managed to design one of the least attractive streetcars ever devised. This equipment study of car No. 21 highlights the enclosed front, the large, gated rear platform with the running board–like steps for sweeping up boarding passengers, and the mesh screens protecting passengers from falling out of the moving cars. It was not pretty, but the design worked.

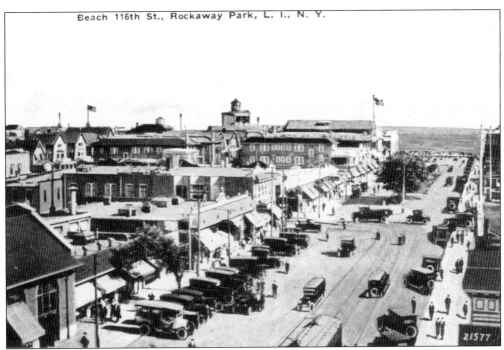

Beach 116th Street was the main drag of Rockaway Park. The peaked-roof building at lower left was the terminal for Long Island Rail Road trains from Brooklyn and from Manhattan's Pennsylvania Station. Note the streetcar entering the bottom of the picture and the early bus parked across the street from it. This view is dated 1925.

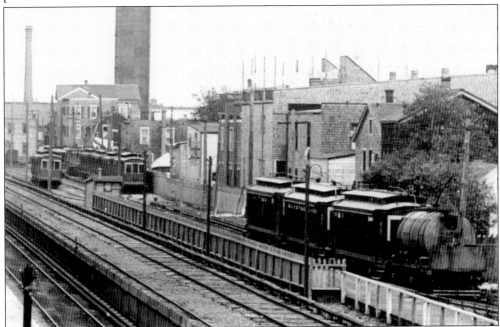

A view of the Rockaway Park yard reveals a fleet of converted open cars plus a sprinkler car (far right) used for watering the summer dust on the streets traversed by these cars. Note the third rail track of host Long Island Rail Road running along the left of the photograph.

With Long Island Rail Road heavy electric cars as a background, Ocean Electric convertible car No. 14 sits in front of the shop building at Rockaway Park. The side panels of convertible cars were removed in the summer, creating a temporary open-car configuration, which allowed passengers to enjoy the sea breezes.

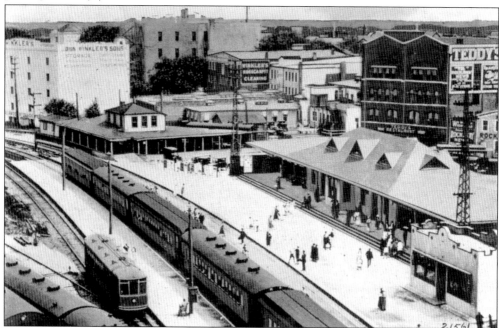

An Ocean Electric trolley car sits among the large electric cars of the Long Island Rail Road at the Far Rockaway station. This was the eastern end of the Ocean Electric's Far Rockaway–Rockaway Park service. The Long Island Rail Road trains ran from here to both New York's Pennsylvania Station and to Flatbush Avenue in Brooklyn.

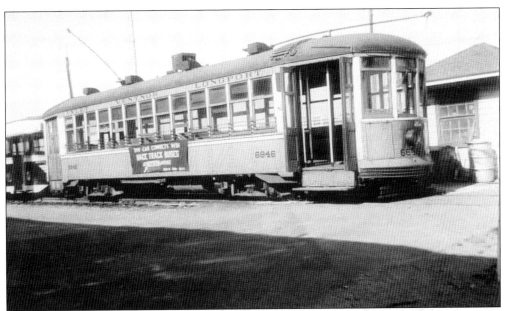

In 1921, the Ocean Electric purchased six cars from the Philadelphia Railways. They were the most modern cars the Ocean Electric ever had. In 1927, near the end of the Ocean Electric's life, all six cars were sold to the Atlantic City and Shore Railroad, where they ran until the end of that company's trolley service in 1955. Atlantic City and Shore Railroad car No. 6846, shown here, was originally Ocean Electric's car No. 36.

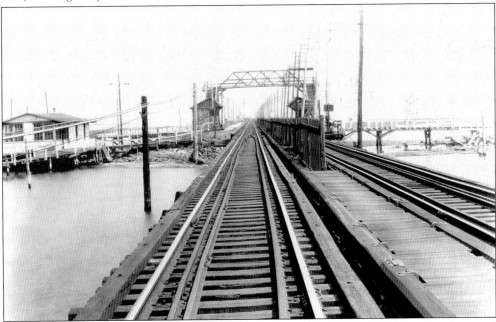

One of the tiniest stations on the Long Island Rail Road's Rockaway Branch was quaintly named the Raunt, and it served a fishing and boating community primarily built on miniscule islands, sandbars, and trestle-type boardwalks. In this 1917 view, it is obviously low tide in Jamaica Bay. To preserve what few potential passengers the Raunt represented, the railroad constructed an elaborate pedestrian overpass, bypassing the deadly third rail.

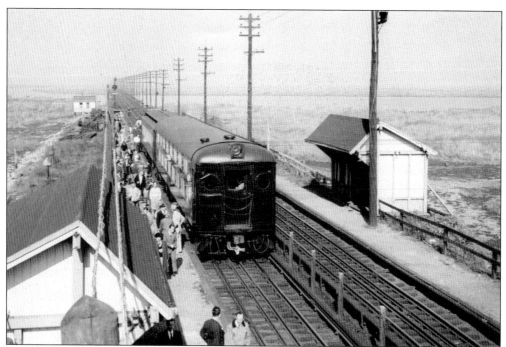

A "rail fan special" train has stopped at the Broad Channel station in the early 1950s. This train is headed by one of the Long Island Rail Road's unique electric double-deck cars.

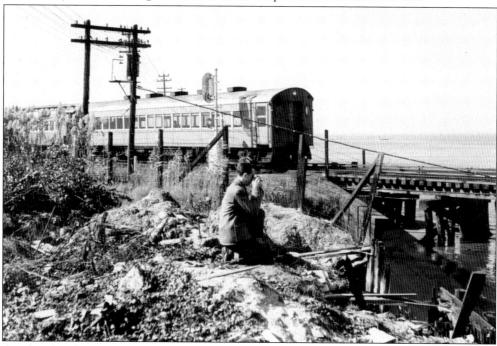

A railroad enthusiast kneels in anticipation of photographing one of the Long Island Rail Road's characteristic arch-roofed electric cars en route to Rockaway Park. The train is entering one of the many wooden trestles over Jamaica Bay. It was a destructive fire on one of them that convinced the Long Island Rail Road to discontinue service on this line.

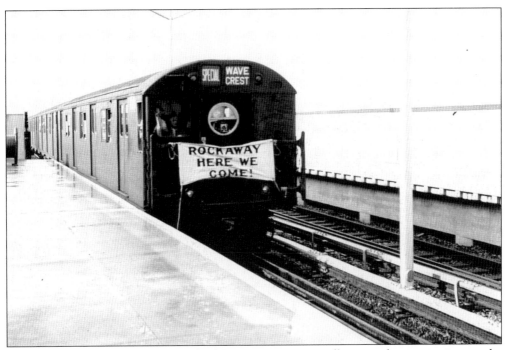

In 1956, the New York City Board of Transportation proudly opened its extension to the Rockaways, both Rockaway Park and Far Rockaway. The photograph shows the ceremonial "first train."

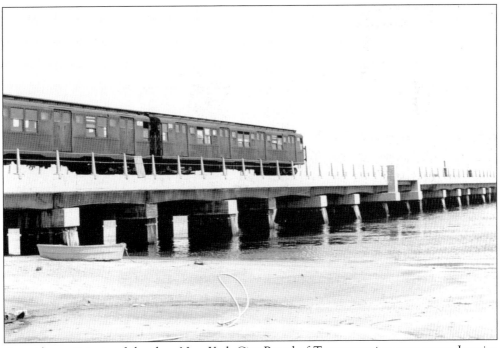

A rapid transit train of the then New York City Board of Transportation runs across Jamaica Bay on a newly constructed concrete trestle that replaced the remarkably flammable creosoted wooden structure formerly maintained by the Long Island Rail Road.

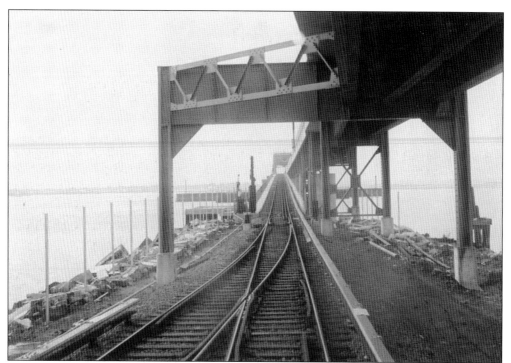

This "flying junction" is the center of operations on the Rockaway peninsula. It routes the rapid transit trains to the two Rockaway destinations: Far Rockaway and Rockaway Park. The line shown ultimately goes to Manhattan via the famed A train route. This structure replaces the famed Hammels Junction of old of the Long Island Rail Road and the Ocean Electric Railway.

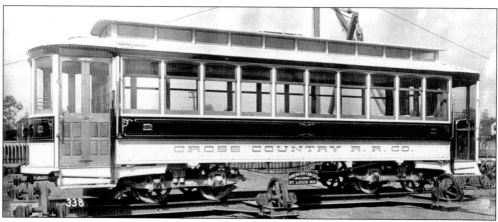

One trolley line never was. The Cross Country Railroad was planned to connect Brooklyn and Queens with Rockaway Park, crossing Jamaica Bay on a long fill. After building commenced, the company ordered cars from the American Car Company, and car No. 2 was completed. However, by that time, the construction had ended prematurely, and the line's franchise was voided. The final disposition of this car is unknown.

Ten

FINISHING THE STORY

The Rockaway story has an odd twist. Out of chronological order but still very important was a scheme proposed by a trio of companies to build a trolley line to serve Rockaway Park from points in Brooklyn and Queens. The combine consisting of the Brooklyn and Jamaica Bay Turnpike, the Rockaway Electric Railroad, and the Cross Country Railroad was chartered in 1898. Each of the component companies was assigned a task. The turnpike company was to build a causeway across Jamaica Bay, connecting Rockaway with the mainland. The Rockaway Electric was to run a trolley line from Far Rockaway to the Holland neighborhood of Rockaway Park, and the Cross Country was to operate the electric line from Holland, across the bay to Brooklyn, connecting with the Brooklyn Rapid Transit's subsidiary, the Nassau Electric, bringing passengers to and from downtown Brooklyn.

Construction began primarily with building the causeway, and an order for new cars was placed with the American Car Company. About this time, the Long Island Rail Road started a long-term delaying tactic that ultimately scuttled this possible competition. But during the prolonged legal war, two unexpected things happened. First of all, the American Car Company built and delivered at least one new streetcar, grandly lettered "Cross-Country R.R. Co.," and the causeway was partially constructed. It is not known what happened to the line's new rolling stock, but the causeway was completed in amended form and now is the basis for that automotive entrée to Rockaway Park, the Cross Bay Boulevard.

So now subway trains roll where trolleys and main line electric trains once ran, and automobiles ply a route designed for streetcars. To paraphrase a fine old saying, "Sometimes things don't turn out the way they were planned."

To finish up the Queens and Long Island story there are some footnotes. For instance, in the years before World War I, an additional joint service to Rockaway Park was offered from Delancey Street, Manhattan, and from Broadway Ferry and Sands Street, both in Brooklyn, via the Brooklyn Rapid Transit elevated service, first using steam trains but later electric trains. The Brooklyn Rapid Transit, operator of street railways and rapid transit in Brooklyn, also had some interesting lines in Queens. For instance, when it extended its Broadway (Brooklyn) elevated rapid transit line to Jamaica, the outer end on Jamaica Avenue ran on the surface and shared tracks with those of the Long Island Traction. Although the surface line was originally accepted by Jamaica burghers, it quickly became unpopular and was replaced by a fully elevated service 14 years later. However, the trolleys continued to use the surface tracks.

Brooklyn Rapid Transit streetcars also ran to Flushing via their Flushing-Ridgewood route. This line, under the successor Brooklyn and Queens Transit, served the 1939–1940 World's Fair at Flushing Meadows. A branch ran along Junction Boulevard terminating at the North Beach amusement area. When the beach became polluted and Prohibition closed the beer gardens, the line was cut back from the amusement park locale, ultimately terminating at the edge of LaGuardia Airport. Another Brooklyn Rapid Transit/Brooklyn and Queens Transit line ran from downtown Brooklyn, bridged Newtown Creek, and ended just above the Interborough Rapid Transit's Vernon-Jackson subway station in Long Island City. For a few years, Myrtle Avenue cars ran from downtown Brooklyn to Myrtle and Jamaica Avenues while Richmond Hill cars were routed from Ridgewood to 168th Street, Jamaica. From Williamsburg Bridge Plaza, the long Metropolitan Avenue line ran to Jamaica while the Grand Street line operated to North Beach, now the site of LaGuardia Airport. And finally, the short Cypress Hills line, a throwback

to the times when the trolley was the only route to Cypress Hill Cemetery, rounded out the Brooklyn and Queens Transit's Queens Street railway coverage.

At one time, the Third Avenue Railway System operated an extension of its 42nd Street crosstown line over the Queensborough Bridge using underground conduit power. The line terminated in Long Island City, and the serviced ended in 1919. Strangely, the conduit rail lay unused on the Queensborough Bridge right-of-way almost until the line was abandoned in 1957.

The New York and Queens County ran trolleys over the same tracks and later turned this service over to the Steinway Lines, which, in turn, bequeathed the trans-bridge section of its system to the Queensboro Bridge Railway when it ended rail service. The bridge railway's cars abandoned their bridge route in 1957, the last trolley service in both New York City and New York State.

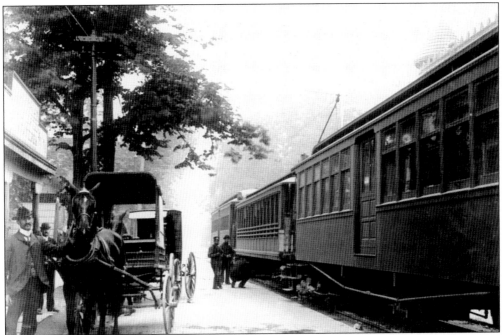

When the Brooklyn Rapid Transit extended its rapid transit line to Jamaica, the outer end ran on the surface in downtown Jamaica. Here, near the transit center at 160th Street, a surface-operating rapid transit elevated train shares the street with other street-using conveyances. The gentleman at the left is holding tight to the horse's rein, making certain that the moving rapid transit train would not spook the horse, causing it to run amok.

At one time, the waterfront at North Beach was a popular summer resort served by multiple trolley companies and their lines. However, pollution killed that aspect, and by the late 1920s, those lines were either abandoned or cut back. The Brooklyn and Queens Transit's Junction Boulevard line was one of the latter. A conflict with the City of New York forced the truncated line to end within sight of LaGuardia Airport but not within its confines. The airport's hangers loom in the background of this photograph.

When the Steinway Lines abandoned its rail operation, its segment across the Queensborough Bridge was sold to the Queensboro Bridge Railway, which intended to use Steinway equipment. However, the City of New York decided that the ancient streetcars had to be modified for "safe bridge operation." While the cars were being updated, the Third Avenue Railway System leased the bridge company some of its newest cars as temporary replacements. One of them is shown leaving the Long Island City end of the Queensborough Bridge in 1939.

A newly refurbished Queensboro Bridge Railway car sits at the Long Island City, Queens, end of the bridge line. The car has had safety equipment added specifically for bridge operation. Two of the most important improvements were the changing from two to four motors per car and the addition of a safety light situated just under the headlight.

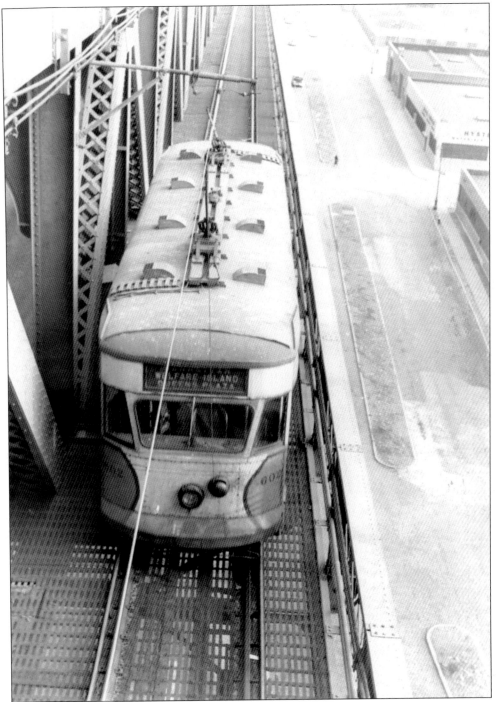

By 1948, the bridge cars were at the end of their physical life and were replaced by relatively modern trolleys of the recently abandoned Union Street Railway of New Bedford, Massachusetts. Here car No. 602 is leaving the mid-bridge Welfare (now Roosevelt) Island station en route to Long Island City. In 1957, these last remaining streetcars in Queens, in New York City, and, in fact, in New York State finally quit.

ACROSS AMERICA, PEOPLE ARE DISCOVERING SOMETHING WONDERFUL. THEIR HERITAGE.

Arcadia Publishing is the leading local history publisher in the United States. With more than 3,000 titles in print and hundreds of new titles released every year, Arcadia has extensive specialized experience chronicling the history of communities and celebrating America's hidden stories, bringing to life the people, places, and events from the past. To discover the history of other communities across the nation, please visit:

www.arcadiapublishing.com

Customized search tools allow you to find regional history books about the town where you grew up, the cities where your friends and family live, the town where your parents met, or even that retirement spot you've been dreaming about.